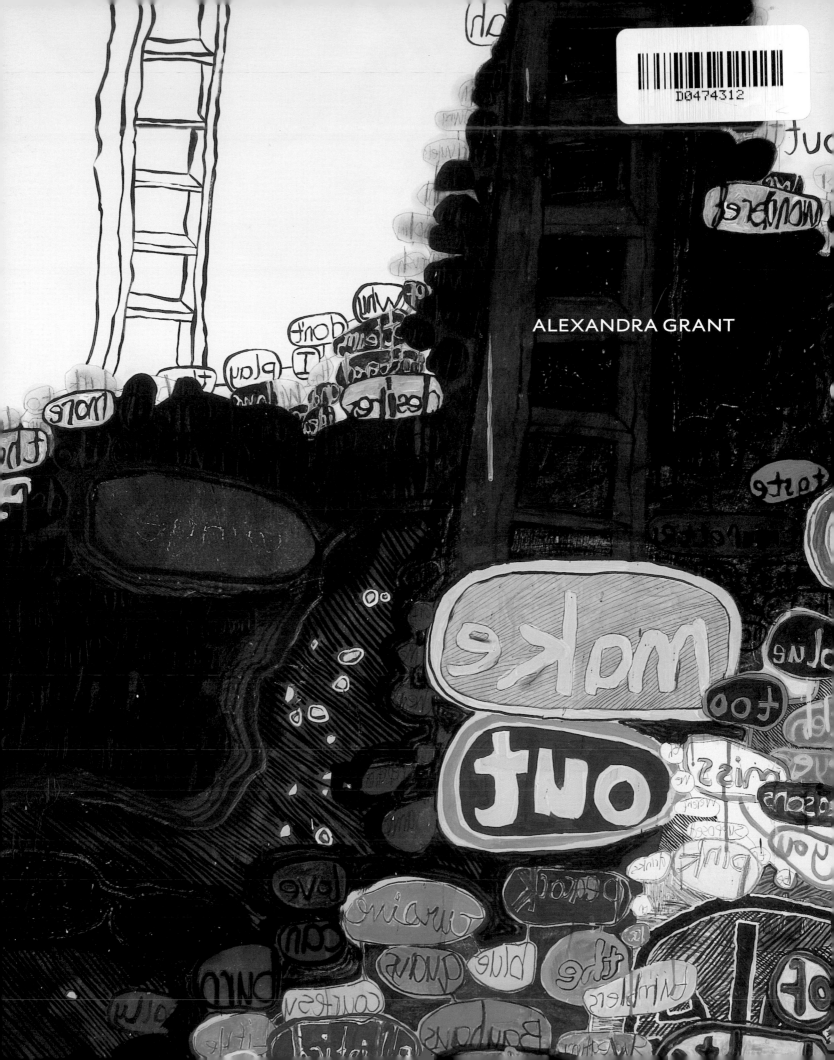

ALEXANDRA GRANT

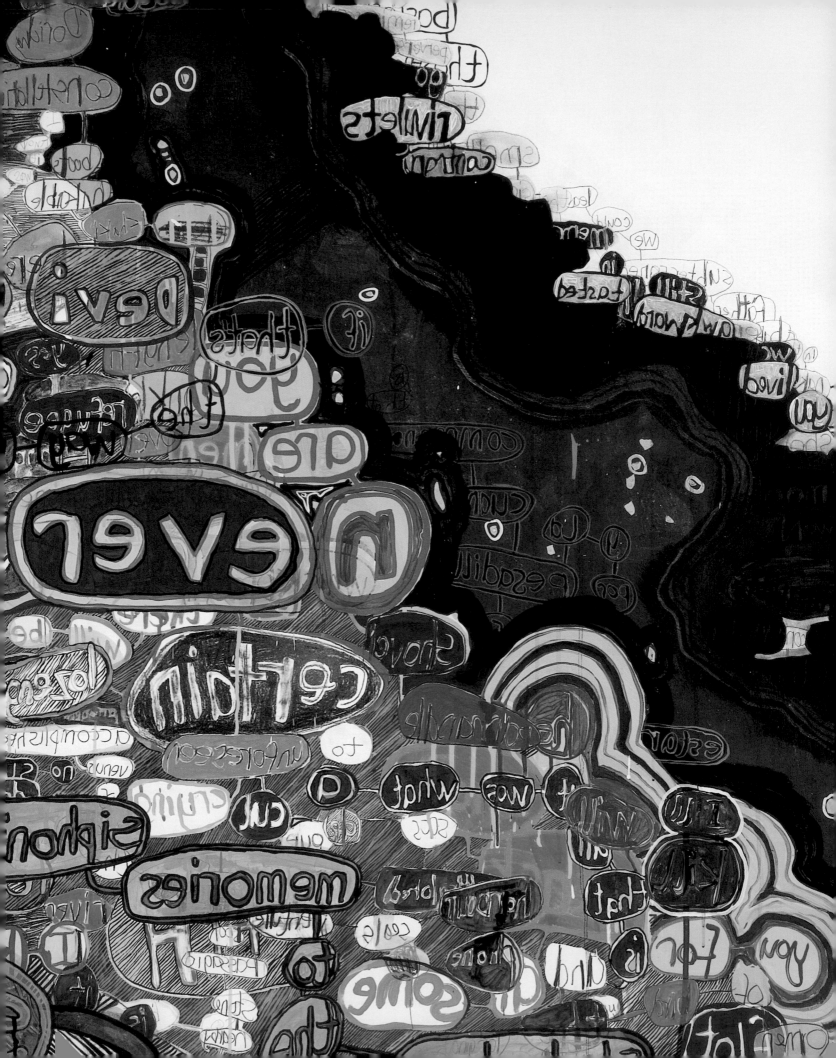

MOCA FOCUS: ALEXANDRA GRANT

Organized by Alma Ruiz

The Museum of Contemporary Art, Los Angeles

COVER
¿dónde está la escalera al cielo?, 2007, detail

PAGES 1 AND 2
babel (after Michael Joyce's "Was," 2006),
2006, details

This publication accompanies the exhibition "MOCA Focus:
Alexandra Grant," organized by Alma Ruiz and presented at
The Museum of Contemporary Art, Los Angeles, MOCA Grand
Avenue, 26 April–13 August 2007.

"MOCA Focus: Alexandra Grant" is made possible by generous
endowment support from The Nimoy Fund for New and
Emerging Artists and the Fran and Ray Stark Foundation Fund
to Support the Work of Emerging Artists.

Major support is also provided by a multi-year grant from
The James Irvine Foundation. Additional generous support
is provided by the Frederick R. Weisman Art Foundation and
David Hockney.

In-kind support is provided by *BPM Magazine*.

DIRECTOR OF PUBLICATIONS
Lisa Gabrielle Mark

SENIOR EDITOR
Jane Hyun

EDITOR
Elizabeth Hamilton

PUBLICATIONS ASSISTANT
Dawson Weber

DESIGN
Michael Worthington &
Yasmin Khan at counterspace

PRINTER
Litho Acme/Transcontinental,
Montréal

PRINTED AND BOUND IN
Canada

ISBN 978-1-933751-01-6

Available through D.A.P./Distributed Art Publishers
155 Sixth Avenue, 2nd Floor, New York, NY 10013
Tel: (212) 627-1999 Fax: (212) 627-9484
dap@dapinc.com

PHOTO CREDITS
Photo: Brian Forrest, pp. 1–2, 10, 18–21, 41, 42, 45, 47, 49,
51, 53, 55, gatefold, 72; photo: Robert Weidemeyer, p. 6;
photo: Alexandra Grant, pp. 12, 14–15, 17, 24; photo: Michael
Worthington, p. 13; courtesy Fundación Gego, Caracas, p. 16;
© 1960 Morris Louis, p. 22; and photo: Joshua White, pp. 67, 69.

CONTENTS

FOREWORD AND ACKNOWLEDGMENTS

Fragments 1–13, 2006, detail
Mixed media on paper
Fragments 1–11: 22 x 15 inches each;
fragments 12–13: 11 x 15 inches each
70 x 69 inches overall
Collection of Janine Arbalaez,
David Chernek, Michael Joyce,
and the artist

With MOCA Focus, The Museum of Contemporary Art, Los Angeles (MOCA), continues its recognition and celebration of the extraordinary community of artists working in Southern California. Throughout its history, MOCA has taken great pride in presenting and, in many cases, premiering the work of young and emerging artists. Over a three-year period, MOCA Focus will present nine solo exhibitions of emerging Southern California–based artists, each constituting that artist's first one-person museum exhibition and monographic catalogue.

MOCA Focus continues a long-standing tradition of solo projects and exhibitions at the museum that reaches back to the In Context series that launched with the opening of The Temporary Contemporary (now MOCA The Geffen Contemporary) in 1983. This series—which included commissioned works and solo exhibitions by Michael Asher, Dan Flavin, Michael Heizer, Douglas Huebler, Maria Nordman, Allen Ruppersberg, Betye Saar, and Robert Therrien, among others—was followed in the 1990s by the Focus series. The Focus series included a wide range of historical and contemporary exhibitions with international, national, and local artists, featuring important solo shows of such Los Angeles–based artists as Amy Adler, Uta Barth, Judy Fiskin, Margaret Honda, Toba Khedoori, and Jennifer Pastor. Then, in 1997, The Citibank Private Bank generously funded the Emerging Artist Award, which gave MOCA a special opportunity to acquire key works and present solo exhibitions by three Los Angeles–based artists: Kevin Appel, Jessica Bronson, and Catherine Opie.

MOCA Focus has been made possible by The Nimoy Fund for New and Emerging Artists, the Fran and Ray Stark Foundation Fund to Support the Work of Emerging Artists, and a multi-year grant from The James Irvine Foundation. We wish to extend our special gratitude to Susan Bay Nimoy and Leonard Nimoy, as well as to James Orders and Elisa Callow, respectively current and former program directors for the arts at The James Irvine Foundation, for their invaluable and enlightened support. Special thanks go to David Hockney for his support of young artists and to the Frederick R. Weisman Art Foundation for its generous support of Alexandra Grant's first site-specific project *¿dónde está la escalera al cielo?* (Where is the ladder to heaven?, 2007), created especially for the exhibition.

Warmest recognition is due to the many exceptional individuals at MOCA, including Chief Curator Paul Schimmel for envisioning this new series. Particular recognition is due to curatorial assistant Cara Baldwin for her able assistance with all aspects of the exhibition. Special thanks are also due to Ann Goldstein, senior curator; Brian Gray, director of exhibitions production; Jang Park, chief exhibitions technician; Sebastian Clough, exhibitions designer and production coordinator; Annabelle Medina, administrative assistant; Melissa Altman, assistant registrar; Susan Jenkins, manager of exhibition programs and curatorial affairs; Cynthia Pearson, administrative assistant; Lisa Gabrielle Mark, director of publications; Jane Hyun, senior editor; Elizabeth Hamilton, editor; Dawson Weber, publications assistant; Jennifer Arceneaux, director of development; Ari Wiseman, assistant director; Jack Wiant, chief financial officer; Suzanne Isken, director of education; Aandrea Stang, education program manager; Rebecca Taylor, public relations coordinator; Cristin Donahue, writer/editor; and David Rager, senior designer/design manager, for their important contributions.

We are grateful to Michael Worthington for his remarkable design of this publication and to Brian Forrest for his fine photographs. We also wish to thank Frederick M. Nicholas and Circa and its extraordinary staff including Tony Nicholas, Eric Gero, and Christianne Dearborn for their creative and technical support in the realization of *¿dónde está la escalera al cielo?*. Special thanks go to Michael Joyce, for the use of his extraordinary texts, and Dan Rothenberg, director of Philadelphia-based Pig Iron Theater Company, and his staff for lending their expertise and voices to the production of the Guide by Cell audiotour of the exhibition. Our deepest gratitude goes to Hélène Cixous for the inspiration her writings provided, both in the creation of the artwork and in the organization of the exhibition, and for allowing MOCA to reprint her essay "The Last Painting or the Portrait of God" as part of this exhibition catalogue.

Our sincere thanks go to Board of Trustees Chair Clifford J. Einstein, President Dallas Price-Van Breda, and Vice Chair Michael Sandler, as well as the entire MOCA Board of Trustees for their commitment and support.

Exhibitions by their very nature are collaborative endeavors, and our last and most thorough thanks and appreciation go to Alexandra Grant for her generosity and engaged participation in all aspects of the exhibition and publication. Alexandra's intelligence, graciousness, and self-assurance is to be admired.

Jeremy Strick
DIRECTOR

Alma Ruiz
CURATOR

ARTIST'S ACKNOWLEDGMENTS

I would like to thank the following people: Alma Ruiz, with deepest appreciation, for recognizing and nurturing me and my work. My mother, Marcia Grant, for everything, including her definition of a creative life. Michael Joyce, my conspirator. Hélène Cixous, who inspires to conspire. Friends, teachers, and supporters, including Janine Arbalaez, Cara Baldwin, Stacen Berg, Sanja Milutinovic Bojanic, Janelle Brown, Josh Cender, Craig Christy, Circa Press, Sarah Cohen, Bruce Falck, Nathan Florence, John Furmanski, Gallery Sixteen:One, Stephen Goldstine, Florence Grant, Norman Grant, Adam Gross, Shona Gupta, Greg Harrison, Sarah Hollinger, Warren Ilchman, Habib Kheradyar, Nellie King Solomon, Los Angeles Contemporary Exhibitions, Lapis Press, Mara Lonner, Ben Lyons, Machine Project, Lisa Gabrielle Mark, Mery Lynn McCorkle, Laura Miller, Anne and Lyle Morton, Eduardo Navas, Kristina Newhouse, Fred Nicholas, Candace Norquist, John O'Brien, John O'Keefe, Rick Pirro, Laura Raicovich, Dan Rothenberg, Colette Sandstedt, Kim Schoenstadt, Sumana Sermchief, Kyungmi Shin, SolwayJones Gallery, Aandrea Stang, Savannah Stevens, Sarah Stifler, Jay Stuckey, Elissa Swanger, Katy Wang, The Frederick R. Weisman Foundation, Sonya White, Mabel Wilson, Michael Worthington, and Jody Zellen. Lastly, I thank Alice Ilchman, to whose memory this catalogue is dedicated.

Alexandra Grant

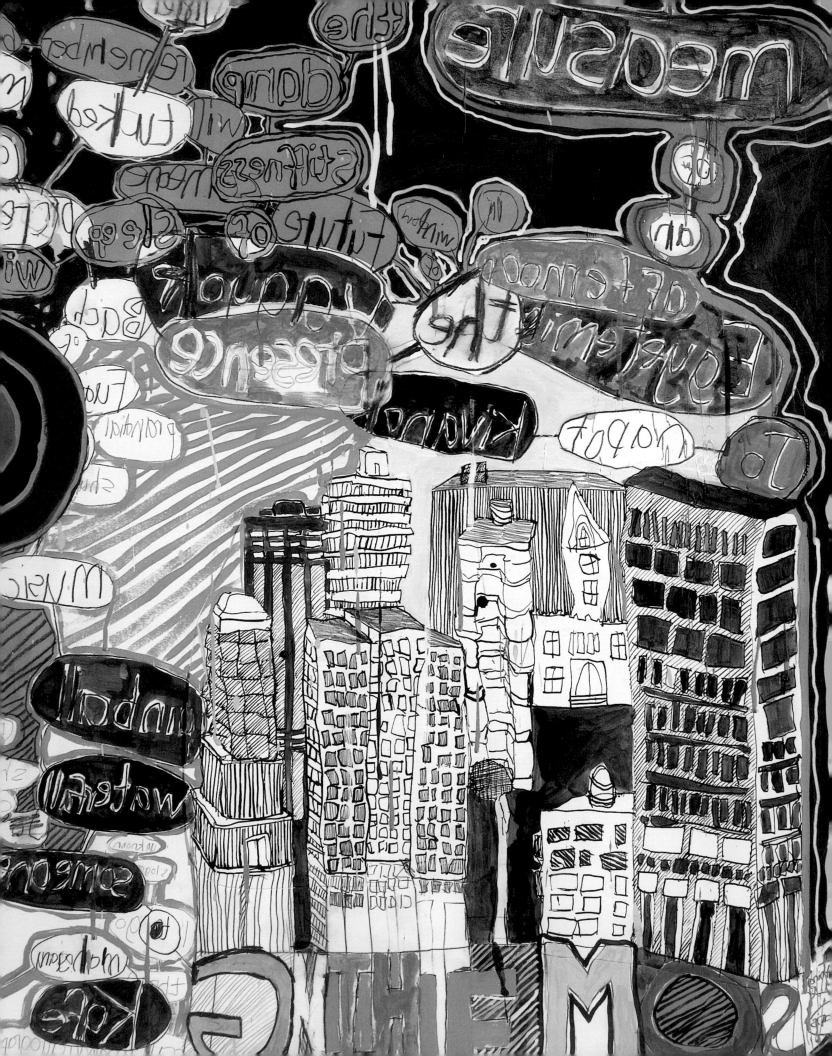

MAPPING LANGUAGE

Alma Ruiz

Do I paint a writing or write a painting?[1]
—ALEXANDRA GRANT

NOTES

1.

Alexandra Grant, conversation
with the author, 7 July 2006.
All subsequent biographical
information and unattributed
quotes are derived from similar
conversations with the artist or
from her unpublished diaries.

*babel (after Michael Joyce's "Was,"
2006), 2006, detail*

Alexandra Grant dates the genesis of her current work to the period between December 1997 and February 1998, when she began "parsing text into chains of words." Around that time, she encountered the writings of Hélène Cixous, whose ideas regarding identity, language, and painting resonated with Grant's own intellectual and artistic pursuits. No less important was her fortuitous discovery in 2003 of the work of American writer Michael Joyce, whose book *Moral Tales and Meditations* (2001) coincidentally features an afterword by Cixous and who has since become a friend and collaborator. Joyce has written texts, both inspired by their ongoing conversations and at Grant's request, that the artist has integrated into her work in various ways. Cixous's writings and Joyce's collaborations have become central to Grant's practice, as manifested in her paintings and sculpture and the site-specific installation created for this exhibition at The Museum of Contemporary Art, Los Angeles. These works are characterized by a visual language in which text, drawing, and painting coalesce in a seamless integration of shapes, colors, and textures.

In 1998, after finishing her first semester of graduate school at the California College of Arts and Crafts in San Francisco, Grant took a leave of absence, during which she immersed herself in the writings of Cixous, Gilles Deleuze and Félix Guattari, Jacques Derrida, Michel Foucault, bell hooks, Maxine Hong Kingston, Julia Kristeva, Clarice Lispector, and Karl Marx. Her reading also extended to Greek mythology, especially plays based on Oedipus and Antigone. The concentrated emotional and intellectual experience of these months prompted Grant to examine her life and probe her identity as a woman, an artist, and an American in a series of diaries.

Grant has been especially influenced by Cixous—in particular, her book *Three Steps on the Ladder of Writing* (1993) became a catalyst for Grant's development of written language into pictorial composition. In Cixous's writing, Grant found a polyvalent and playful voice addressing language from the perspective of a philosopher, woman, and immigrant. Born in Algeria,

Reach (after Michael Joyce's "Reach"),
2003, detail
Wire, colored pencil, and lead on paper
122 x 80 inches
No longer extant

Cixous was raised speaking German (her mother was Austro-German) but moved to France as a young adult and began writing in French; in texts addressing poetry, painting, motherhood, and mother tongue, Cixous finds her identity through language. Similarly, Grant's childhood was variously spent in Mexico, Spain, France, and the United States speaking Spanish, French, and English. Facing some of the same issues as Cixous, she finds her identity not as a writer but as a painter of language.

After a short time as a student of architecture at Princeton University and a consultant for La Colección Patricia Phelps de Cisneros, New York, Grant left the East Coast in 2001 and moved to Los Angeles to pursue a career as a visual artist. There, Grant continued to visually map out "bubble poems," which had first appeared in her diary. These featured words encircled by balloons along with sentences like "I want to publish image/texts" or "text/image—my concern is where they blur." The incipient diagrams slowly transformed from circles strung like holiday lights along connecting lines into the densely overlapping loops that are characteristic of her current work. Cixous's theories of language opened up the possibility of working as a painter who uses language. In "The Last Painting or the Portrait of God" (1986), Cixous wrote: "the lesson is: one does not paint ideas. One does not paint 'a subject.'... And in the same way: no writing ideas. There is no subject. There are only

2.

Hélène Cixous, "The Last Painting or the Portrait of God" (1986), in *"Coming to Writing" and Other Essays*, ed. Deborah Jenson (Cambridge, Massachusetts: Harvard University Press, 1991), 124.

Page from Grant's diary, 1998

mysteries. There are only questions."[2] For Grant, the idea of leaving something open-ended was both terrifying and appealing. She began to think of words as "things" to be manipulated, writing them in reverse from right to left—as in Hebrew and Arabic—with her left hand in order to thwart conventional comprehension of the text. In her diary from 1998, Grant mapped out a series of word balloons using various languages, including Spanish ("sueño con México" [I dream of Mexico]) and French ("aidez moi, aidez moi" [help me, help me]). Another entry references Leonardo da Vinci, who wrote his scientific manuscripts backwards. Her awkward entries reveal an unsure hand that had yet to master this novel way of writing, but since then Grant has become very proficient. Her technique de-emphasizes the narrative qualities of the work, reorienting the eye to a more balanced reading of space, color, texture, and form that is evident in The Ladder Quartet (2004–05), a series of four drawings made in homage to Cixous after texts by Joyce.

Grant's interest in translation encompasses not only translation from one language to another but also from text to image, spoken language to written word, and two to three dimensions. Early paintings made in school, such as The Tallest Story I've Ever Written (1997), featured her own writing transposed onto large-scale canvases. Although very few survive—some exist only in documentary form—they helped form her ideas about mapping language visually. Their low survival rate is due in part to Grant's ongoing practice of reusing canvas or paper from old works. For example, Reach (after Michael Joyce's "Reach") (2003), a large drawing that explores the nexus between the topographical and the textual, was first exhibited in "Mind's Eye" at SolwayJones Gallery, Los Angeles, in 2003, then reappeared in the exhibition "Draw a Line and Follow It" at Los Angeles Contemporary Exhibitions in June 2006 totally transformed under the lengthy title Twin Portraits at the Periphery of a Flux (Fifth Iteration) (after the texts "Twin Portraits at the Periphery of a Flux," "Untitled Song," and "Fluxus Score" by Michael Joyce, 2006, and "Observatory" by Robert Watts). This pragmatism can be disconcerting until one realizes that her habit of recycling is consistent with her interest in translation—to Grant, an artwork is not destroyed so much as reinterpreted.

Light in New York this twilight,
2004, detail
Mixed media on paper
24 x 18 inches
Collection of the artist, Los Angeles

3.

Michael Joyce, email correspondence with Grant, unpublished manuscript, 2003–06. *Indécritions* evolved from a consideration of the French verbs *écrire* (to write) and *décrire* (to describe) that led to *indécrit*, a noun that means "the undescribed." Joyce fabricated the word *indécritions* to resemble the English "indiscretions."

4.

Grant, email correspondence with Joyce, unpublished manuscript, 2003–06.

5.

Joyce, ibid. Collaborating with artists is not new to Joyce. He is currently working on an opera with Venezuelan video artist Anita Pantin, for which he will provide the libretto.

On Collaborating: *Indécritions*[3]

Grant's collaboration with Joyce, a well-known poet, writer, pioneer and theorist of hypertext, and professor of English and media studies at Vassar College in Poughkeepsie, New York, began during spring 2003, when she emailed him to request the use of his text "Reach, a fiction" (2000), which includes a section called "Domesticity." Grant was researching the subject for a curatorial project and was looking for a writer open to collaborating with a visual artist. In the past she had borrowed from the work of poets such as Wislawa Szymborska and Constantine P. Cavafy; however, her goal was to find a living poet with whom to have an active exchange. To her surprise, Joyce responded within days to say he would be delighted. Though Joyce once wrote a text based on some drawings Grant had sent him, for the most part their collaboration has involved discussion and the joint selection of a subject, after which Joyce writes a text based on their conversations. Grant then reacts to his text or becomes inspired by it, ultimately translating it into images. This methodology evolved through face-to-face meetings, frequent verbal and written communications, a collaboration on an art exhibition, and joint lectures at Notre Dame University in South Bend, Indiana, and California Institute of the Arts in Valencia.

Grant has said that her collaboration with Joyce was born out of curiosity. As a painter she was concerned with "the role language plays in the causality of things and the emotional states."[4] She has often said that her trilingualism is a central part of why her work is text-based. For Joyce, their association represented the opportunity for further exploration into the increasing dominance of image over written word.[5] Joyce's texts inspired Grant's *nimbus I (after Michael Joyce's "Nimbus")* (2004), The Ladder Quartet, *ladder* (2005), and *babel (after Michael Joyce's "Was," 2006)* (2006). For *Light in New York this twilight* (2004), Grant made a small drawing about the differences in the quality of light between New York and Los Angeles and sent it to Joyce so that he could use it to write a longer text. According to Joyce, the texts he writes are gifts to Grant she may keep and use as she pleases. They have been employed as "scores" to make new paintings and displayed publicly, posted next to the artworks they inspired and on her website. It is rather uncommon to find such generosity in a writer; however, working in the realm of hypertext, Joyce freely disseminates much of his work via the internet, perhaps making him less proprietary.

Grant now does not use her own writing for her paintings, sculptures, or installations, believing it to be too close to her to be effective. However, her own writing occasionally serves as the basis for small drawings that tend toward free association. *let me know when you are in* (1999/2006) and *let me know when you* (1999/2006) are small drawings Grant showed together in "Painting Fiction, Fiction Painting" at the Brewery Project, Los Angeles, in May 2006. Their almost identical titles seem to be part of a casual conversation cut short. Other phrases are contained in the drawings, including "did not to her own chagrin, que pena" (Spanish for "what a pity") and "could have been that is arranged," which seem to support this perception.

6.

Grant, in conversation with Cixous, Peggy Kamuf, and Alma Ruiz, 12 February 2006.

*I prefer, drawing without paper
(after Wislawa Szymborska)*, 2002

Wire, pencil, and shadow
19 x 12 x 1 inches
No longer extant

The Casting of a
Shadow by Language[6]

Grant also makes sculptures out of thin silver wire or neon that she described as "spider webs of language"; hanging on a wall or from a ceiling, these works map texts three-dimensionally in a way that resembles her two-dimensional works. *I prefer, drawing without paper (after Wislawa Szymborska)* was made for the 2002 exhibition "unDRAWN: Unusual Approaches to Drawing" at the Brewery Project. Balloons with the words "I prefer" become nodes that are connected by lines of wire. *I prefer* takes its name from a phrase repeated in "Possibilities," a poem by Szymborska. Using a translated work by a non-English–speaking author, Grant was interested in exploring the transformation of language through translation, in particular what is lost and gained semantically during such a process. In Szymborska's poem every line begins with the phrase "I prefer" ("I prefer movies. / I prefer cats. / I prefer the oaks along the Warta. / I prefer Dickens to Dostoyevsky. / I prefer myself liking people to myself loving mankind."). *I prefer* was mounted so that it cast a shadow on the wall that the artist recorded by tracing it with a pencil. The wire sculpture, its shadow, and the pencil drawing create an echoing of forms, a play of material and immaterial. The drawing lends the delicate sculpture a sense of presence.

Similarly, *nimbus I* hangs from the ceiling and casts shadows on the wall but also rotates on its axis, powered by a small motor. The literary source for *nimbus I* is a short text by Joyce, written after Grant told him she wanted to create a spinning silver nimbus of wire filigree. The piece hangs in the gallery, suspended like a cloud, and extends Grant's signature word bubbles into three dimensions. The reflected words are fugitive, never lingering long enough for one to be able to read them. However, the piece entices the viewer to try in the hope that its meaning will be revealed in time. Both *nimbus I* and *I prefer* are characterized by an element of secrecy that is present in all of Grant's language works. Deciphering a word or a word fragment does not lead one to understand the work; rather, the language that lends shape to the works ironically also frustrates the pursuit of meaning.

nimbus I and *I prefer* render language impermanent and immaterial by the presence of light and movement. Formally, Grant's wire sculptures recall the Reticuláreas of Venezuelan artist Gego, as well as her more delicate wire drawings. Like Gego, Grant explores the possibilities of organic structure through weblike constructions, the visual interplay between light and shadow, and the idea of dematerialization.[7] However, Grant's work derives from language and ideas about information networks, whereas Gego's sculptures reference organic forms found in nature.

To date, Grant has made one neon work, *yo soy lo que veo (after Jorge Volpi after Erwin Schrödinger)* (2004). "Yo soy lo que veo" is a quote from Volpi's award-winning novel *En busca de Klingsor* [In search of Klingsor, 1999] about a German scientist working on the atomic bomb during World War II. Neon was popularized as a medium for art during the 1960s by such artists as Mario Merz and Pier Paolo Calzolari in Italy

and Bruce Nauman in the United States. *Yo soy lo que veo* consists of words enclosed in interconnecting balloons that, read top to bottom and left to right, declare "I am what I see" in glowing pink. The fragmentary nature of the phrase "yo soy lo que veo" resembles the more hermetic language found in Grant's sculptures.

Grant refers to these sculptures as "drawings without paper," a phrase borrowed from Gego, who coined it in relation to her own work. The wire sculptures later became the source for Grant's wallpaper project *¿dónde está la escalera al cielo?* (Where is the ladder to heaven?, 2007), which arose out of the artist's experiments with digital printmaking. Scanning her silver wire sculptures, Grant created a two-dimensional work intended to extend over a wall surface like a rhizomatic system that, in theory, can grow in all directions infinitely.

7.
For more information on Gego, see my "Open Up," in *The Experimental Exercise of Freedom: Lygia Clark, Gego, Mathias Goeritz, Hélio Oiticica, and Mira Schendel*, exh. cat. (Los Angeles: The Museum of Contemporary Art, 1999), 23–25.

16

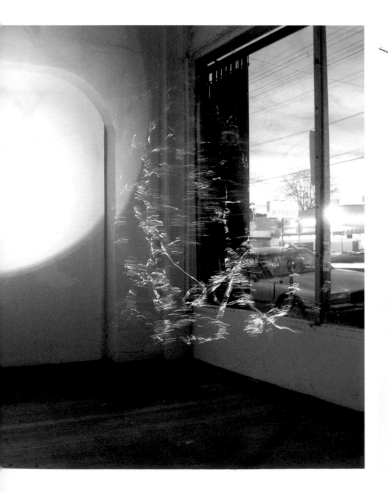

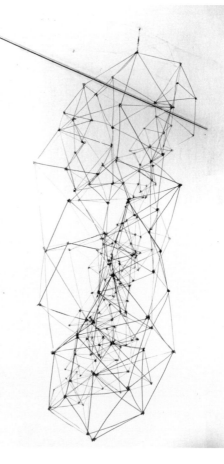

LEFT
nimbus I (after Michael Joyce's "Nimbus"), 2004
Wire, shadow, motor, and light
80 x 62 inches
No longer extant

RIGHT
Gego
Chorro, 1988
Stainless steel rods
78 3/4 x 39 3/8 x 27 9/16 inches
Colección Mercantil, Caracas

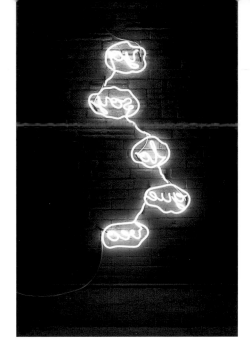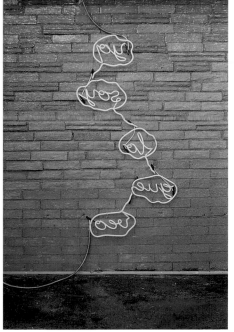

yo soy lo que veo (after Jorge Volpi after Erwin Schrödinger), 2004, night and day views
Neon
60 x 72 inches
Collection of the artist, Los Angeles

The Ladder Quartet

8.

Cixous, " The Last Painting or the Portrait of God," 114.

9.

The artist refers to her large-scale works as "drawing-paintings."

Inspired by Cixous's description of herself in "The Last Painting" as a writer "with brushes all sticky with words,"[8] Grant became intrigued with the notion of a writer who thinks of herself as a painter, leading her to reverse the analogy to envision a painter who thinks of herself as a writer. The Ladder Quartet, a series of four large-scale "drawing-paintings,"[9] represents the result of this line of inquiry. She and Joyce had discussed the symbolism of the ladder, talking about its meaning in the work of James Joyce, in the biblical story of Jacob's Ladder, and in Cixous's book *Three Steps on the Ladder of Writing*, an investigation into the writing process. From these conversations, Joyce produced four short texts: "he taking the space of," "ladders," "conspire (for H.C.)," and "contend (for N.B.)." These inspired four large works by Grant with the titles *she taking her space (after Michael Joyce's "he taking the space of," 2004)* (2004); *let's (after Michael Joyce's "Ladders," 2004)* (2005); *conspirar (after Michael Joyce's "Conspire," 2004)* (2005); and *contender (after Michael Joyce's "Contend," 2004)* (2005). Though Joyce wrote his texts in English, Grant translated "conspire (for H.C.)" and "contend (for N.B.)" into Spanish and proceeded to work with the translations. For Grant, translating the texts into Spanish was her way of taking possession of them. "conspire (for H.C.)" and "contend (for N.B.)" were written during one of Joyce's visits to Los Angeles in fall 2004 on a research grant from Vassar, during which Grant invited him to try his hand at painting in her studio. Both texts were inspired by Nora Barnacle, James Joyce's wife, though only one mentions her by name.

Executed in Grant's small studio, the works are as high as the studio walls, their verticality necessitated by the studio's narrow configuration.

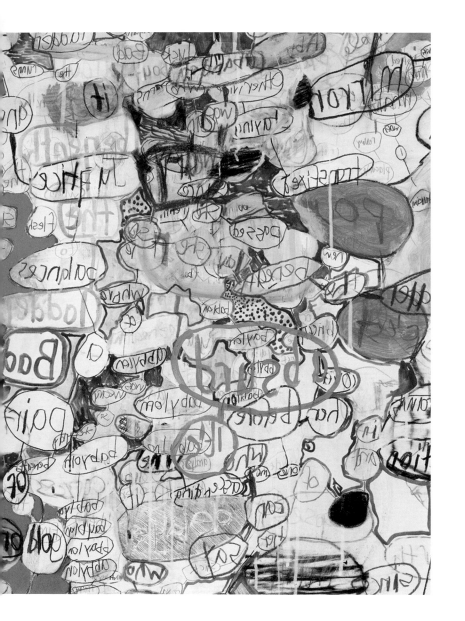

she taking her space (after Michael Joyce's "he taking the space of," 2004), 2004, detail

Hung a few inches off the floor and resembling a large door, they alter the spatial relationship between the artwork and the viewer. Grant has described their creation more in terms of writing than painting: first she wrote on paper, later editing and inserting sentences and words, slowly building its surface with many layers of paint (and, in the case of *she taking her space*, collage). Interspersed among the loops of text are renderings of ladders. Each work in The Ladder Quartet was made according to self-imposed rules that involved using, or avoiding the use of, a particular color or colors, giving each of the works a distinct character and appearance.

The selection of pink in *she taking her space* was intended to cause friction between two opposing desires: wanting to paint everything pink (one of Grant's preferred colors) while trying to resist doing so. Pink appears on the left, with gray on the right and a large central white zone spreading outward toward the edges. Enclosed in balloons, the text spreads upward in an ascending motion, visually aided by the ladders in the lower and middle registers. Paint drips counterbalance this effect as they travel toward the bottom. Grant's handwriting looks timid and unsure in some areas—her hand still fighting the unnaturalness of writing backwards—but the word balloons on the right express more confidence, their lines heavy and precise, the words themselves bigger, bolder, and easier to read. Centered at the bottom edge are two ladders resting on clouds, while nearby another seems to be floating. The effect is both mystical and cartoonish. Are the ladders being transported to heaven on puffy clouds, as if they were virgins or saints? By placing them close to the bottom edge, Grant seems to imply that the entire composition of *she taking her space* rests on the ladders.

For *let's*, Grant chose orange, turquoise, and yellow—three colors she would not normally use together. The result, however, is a radiant painting in which the word "let's" forms the visual structure from which other sentences originate. There are instances in which Grant does not use Joyce's texts intact but responds to them, replacing some of his words with her own writing or allowing her response to become part of the piece. Here, she reacted to the relentless iteration of the word "let's" in Joyce's text by inserting a cluster of negations ("no," "no," "no") in various areas of the composition. *let's* reveals a greater ease and assuredness in the encircling and overlapping of the words to create an appealing density of signs. Ladders of various lengths and thicknesses appear throughout connecting word clusters, deftly guiding the eye up and down and across the work's surface.

The title of the third work in the series, *conspirar*, or "to conspire," is a direct allusion to Grant's and Joyce's relationship to each other and to Cixous.[10] Joyce's text for this work centers on these relationships, and

10.

After years of reading Cixous's texts, Grant was able finally to meet her on December 27, 2003, thanks to Joyce, who arranged a rendezvous in Paris. In January 2006, Cixous visited Grant's studio.

let's (after Michael Joyce's "Ladders," 2004), 2005

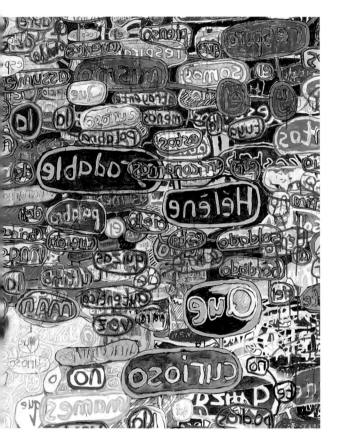

conspirar (after Michael Joyce's
"Conspire," 2004), 2005, detail

the name Hélène hovers in the center of the composition in dedication. Grant wanted a "Catholic" color (even though Cixous is Jewish) and settled on ecclesiastical purple, which evokes the regal as well as the feminine. Overlapping word balloons cover most of the work's surface, except for a wide area in the bottom left where an oversized ladder leans near the edge of the paper. As in the other Ladder Quartet works, images of ladders are interspersed with text. Grant elected to use Spanish instead of English or French, perhaps as a way of returning to what Cixous calls the "mother tongue."

For the fourth and last work in the series, Grant decided to use a range of colors including black, which she had intentionally avoided up to that point, feeling that it tends to define a piece too graphically. In *contender*, the scale of the words grows, and a monolithic mass of overlapping forms is concentrated in the center and the right side. Near the center, the word "espacio" (space) looms larger than anything else, apparently referring to the big empty space on the upper left. The ladders on the left side of the composition separate the text from large empty expanses of white paint. Using the shallow perspective of Oriental drawings, the composition hovers over the surface of the picture plane.

As she was finishing The Ladder Quartet, Grant became interested in landscape, which led her to the creation of *babel (after Michael Joyce's "Was," 2006)*, a twenty-two-foot-long painting also based on a text by Joyce that is her most ambitious work to date. Much informed by their collaboration and thinking about networks, Joyce had just completed the novel *Was: Annales nomadique/A novel of internet*, which comprises a "horizontal" structure that "moves from landscape to landscape around the world, progressing through a series of consciousnesses in something of a (st)ages of (wo)man progression."[11] Electric, fast-paced, and enriched by a variety of languages, local slang, and physical sites, Joyce's novel conveys the stimulating, polyglot, and sometimes terrifying environments of today's large cities.

babel is divided into three parts featuring two sides sloping into a central valley, a division of space found in works such as Morris Louis's *Alpha Ksi* (1960–61), in which paint has been poured from the top right and left edges to form slanting skeins of color, leaving the center open and untouched. According to Grant, "*babel*, in its finished form, plays with some of the stylistic tropes that work successfully in Louis's painting. The immense, central white space sits both in front of the image and simultaneously in the back, as part of the wall."[12] A similar spatial structure is also found in the landscapes of Caspar David Friedrich, the nineteenth-century German Romantic painter. In Friedrich's *Chalk Cliffs at Rügen* (1818–19), for example, white

11.

Joyce, email correspondence with Grant.

12.

Grant, email correspondence with the author, 15 November 2006.

babel (after Michael Joyce's "Was," 2006), 2006

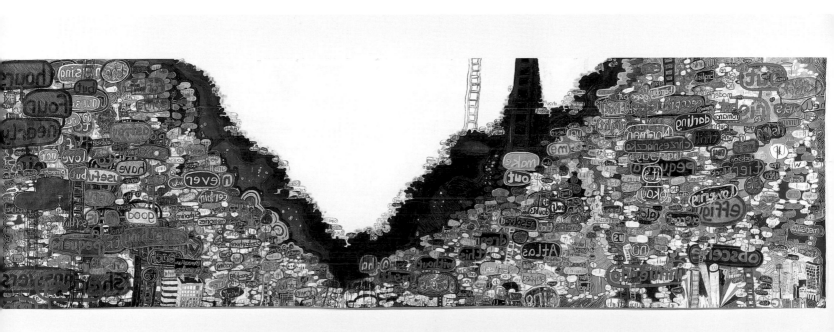

cliffs frame the sky and the receding sea, making the vast expanse of air and water the focus of the composition. The surrounding landscape—including three figures and two large trees—frames the cliffs, filling up the four corners of the canvas. Similarly, for *babel*, Grant painted a scalloped black band to set off the white central expanse. The inverted perspective helps keep the focus of the composition front and center. The word balloons cluster on the slopes and overlap like trees in a mountainous forest, while along the bottom edge, several architectural structures appear, including skyscrapers bearing rooftop billboards that form a city skyline. The sheer scale of *babel* requires that one step back a certain distance to view the entire painting. However, the division of space into three distinct sections facilitates the comprehension of its complex composition when viewed from a short distance, ensuring that it avoids the visual monotony that can develop on an exaggeratedly horizontal landscape. In addition to that of Louis and Friedrich, *babel* makes reference to the work of Jackson Pollock, whose name appears in small yellow letters on the right side of the painting. His work is evoked by the application of multiple layers of paint, the drips that populate the painting's surface, and the sheer physicality of *babel*'s scale.

22

Morris Louis
Alpha Ksi, 1960–61
Acrylic on canvas
103 x 174 inches
The Nelson-Atkins Museum of Art, Kansas City,
Missouri, gift of the Friends of Art

The ladder continues to be a motif that Grant deploys in her work. In *babel*, the ladders have grown in size, and some have metamorphosed into towers. One in particular seems to connect a word bubble with the top edge of the paper. Distinctly drawn near the center of the composition, the ladder is painted green against a black background. *babel* clearly evokes the ascending or descending movement of ladders, which have a positive connotation in many mythologies: climbing a ladder may symbolize progress or even ascension into heaven. However, the ladder can also be a source of pain and misery: falling from a ladder can be fatal, and walking under one is thought to bring bad luck. In Grant's works, the ladder signifies communication and interconnectedness, much like Jorge Luis Borges's "The Library of Babel," a magical world of hexagonal rooms, bookcases, hallways, and spiral staircases. Grant's works can also be magical, their multiple webs of language trapping unimagined meanings.

Grant's visual investigations into mapping language are the result of affinities and collaborations she has sustained with writers throughout her career. Whether by immersing herself in their writings or by pursing intellectual exchanges, she has found these relationships to be a fertile ground on which to test her thinking. If, as Cixous wrote, "writing, like painting, is a risk for the writer," the inverse is true for Grant—painting, like writing, is a risk for the painter. She has been willing to take that risk, and in so doing she has followed Cixous's exhortation to take a leap and "fall not like a stone, but like a bird."[13]

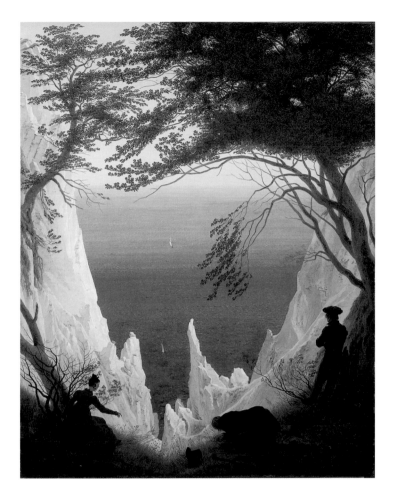

Caspar David Friedrich
Chalk Cliffs at Rügen, 1818–19
Oil on canvas
35 7/16 x 27 9/16 inches
Museum Oskar Reinhart am Stadtgarten,
Winterthur, Switzerland

13.
Cixous, *"Coming to Writing"*, 40.

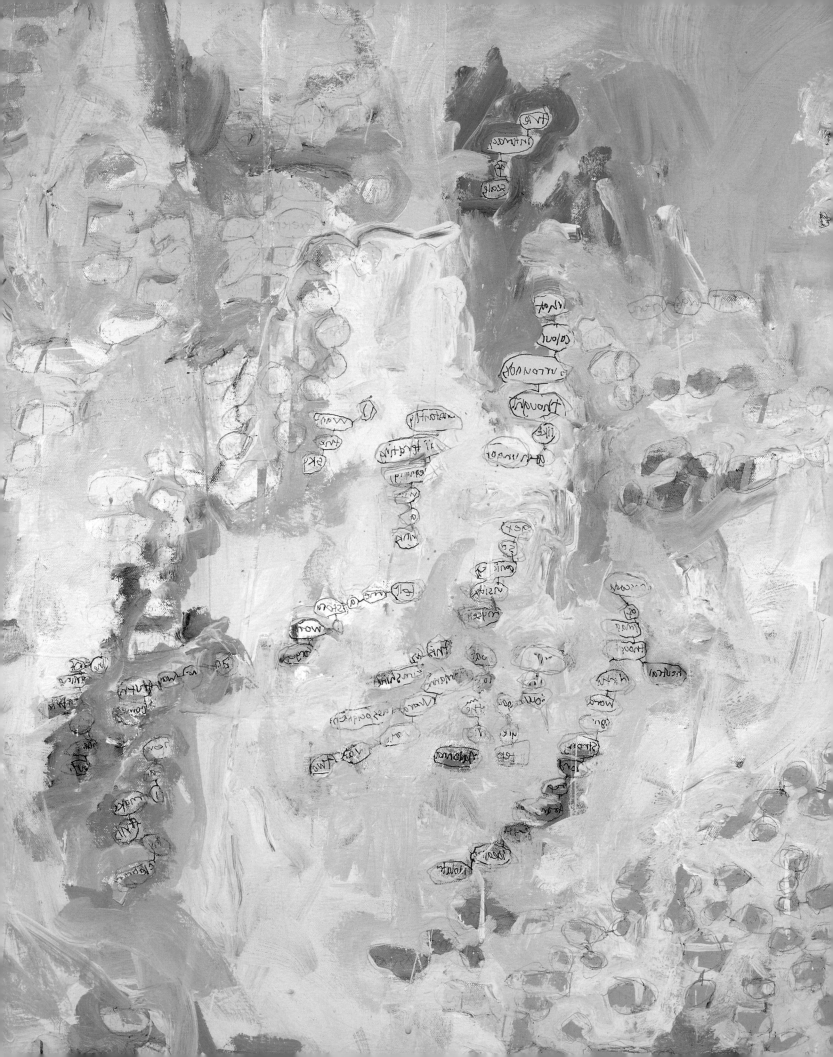

THE LAST PAINTING OR THE PORTRAIT OF GOD

Hélène Cixous

NOTES

" The Last Painting of the Portrait of God," reprinted by permission of the publisher from *"Coming to Writing" and Other Essays* by Hélène Cixous, edited by Deborah Jenson, pages 104–31, Cambridge, Massachusetts: Harvard University Press, Copyright © 1991 by the President and Fellows of Harvard College.

1.

Claude Monet, letter to Gustave Geffroy, in *Claude Monet at the Time of Giverny*, ed. Jacqueline and Maurice Guillaud (Paris: Guillaud, 1983), 80.

palimpsest (pink), 1999, detail
Acrylic on canvas
66 x 72 inches
Collection of the artist, Los Angeles

I would like to write like a painter. I would like to write like painting.

The way I would like to live. Maybe the way I manage to live, sometimes. Or rather: the way it is sometimes given to me to live, in the present absolute.

In the happening of the instant.

Just at the moment of the instant, in what unfurls it, I touch down then let myself slip into the depth of the instant itself.

This is how I live, this is how I try to write. The best company for me is she or he who is in touch with the instant, in writing.

And what is a painter? A bird-catcher of instants.

"I will have to work very hard to render what I am looking for: the instantaneous impression, particularly the envelope of things, the same all-pervading light."[1]

Monet, in 1890, is the one who said that: what I am looking for, instantaneousness… the same light spread throughout, the same light, the same light.

There is a literary *oeuvre* which is dear to me, the work of Clarice Lispector. She wrote *Agua Viva*. This book aims to write-paint, aims to work on the gesture of writing as a gesture of painting. I say "aims": one can always ask oneself the question of the reality of the thing. What brings this book closer to a painter's gesture is that it is a book of instants, a book from which each page could be taken out like a picture. Clarice says: "Each thing has an instant in which it is. I want to take possession of the thing's *is*."[2]

I want to take hold of the third person of the present. For me, that is what painting is, the chance to take hold of the third person of the present, the present itself.

But in life, it is "only in the act of love—by the clear, starlike abstraction of what one feels [that] we capture the unknown quality of the instant, which is hard and crystalline and vibrant in the air, and life is that incalculable instant, greater than the event itself."

Who could write: "Is my theme the instant? my life theme. I try to keep up with it, I divide myself thousands of times, into as many times as the seconds that pass away, fragmentary as I am and precarious the moments."[3] It may be Clarice Lispector, it may be Monet.

I would like to write to what is living in life; I would like to be in the sea and render it in words. Which is impossible. I would like to write the rose-colored beach and the pearly ocean. And it is February. Completely impossible. My words can't tell you the simultaneously infinite and yet finite beach rolled out like an immense carpet of rosy sands. My words are colorless. Barely sonorous? What I can tell you, a painter would show you.

2.
Clarice Lispector, *The Stream of Life*, trans. Elizabeth Lowe and Earl Fitz (Minneapolis: University of Minnesota Press, 1989), 3.

3.
Ibid., 4.

4.
Monet, letter to Alice Hoschede, in *Claude Monet at the Time of Giverny*, 27.

I would like to break your heart with the magnificent calm of a beach safe from man. But I can't do it, I can only tell it. All I can do is tell the desire. But the painter can break your heart with the epiphany of a sea. There's a recipe: "To really paint the sea, you have to see it everyday, at every hour in the same place, to come to know the life in this location."[4]

That's Monet. Monet who knows how to paint the sea: how to paint the sameness of the sea.

It's in vain that I say to you: Côte Rocheuse, Lion's Rock, Belle-Ile. And the green sea and the black lion don't fall on your heart over and over. I tell you of the rocks at Belle-Ile. But eternity doesn't suddenly stream forth and enter, weeping, through your eyes into the depths of your body.

With a haystack, I tell you "haystack," I don't reveal the setting sun to you, I don't intoxicate you with the discovery of the colors in the light, I don't make you laugh, I don't make you cry. I write.

I love paintings the way the blind must love the sun: feeling it, breathing it in, hearing it pass through the trees, adoring it with regret and pain, knowing it through the skin, seeing it with the heart. I don't paint. I need painting. I write in the direction of painting. Position myself toward the sun. Toward the light. Toward painting.

The blind don't see the sun? They see the sun in a different way. And perhaps I, in writing, paint in a different way. I paint in the dark. But this is my blind way of calling forth light.

I'm calling.

There are mimosas in the garden. I want so much to give them to you to see.

I am only a poet, I am only a poor painter without canvas without brush without palette.

But not without God; being only a poet, I am really obligated to count on God, or on you, or on someone.

I'm calling: Mimosa! I'm calling you.

I tell you on the telephone: I want so much for you to see the mimosas. I send you the word "mimosa"; I hope that once delivered to your breast, it will transform itself into a vision of mimosa. I am a being who paints mimosas by phone.

If I were a painter! I would give you each mimosa-cluster whole. I would give you my mimosa-soul, down to the most minute quivering of the yellow spheres.

I would put my mimosoul on the canvas, before your eyes. But I don't paint. I can only speak to you of mimosas. I can sing the word "mimosa." I can make the magic name ring out, the mimosa word: I can give you the music of the mimosa. I can swear to you that (the) mimosa is a synonym for alleluia.

And still, how fortunate that there is the word "mimosa"! I can tell you that the mimosa mimes. I can tell you, too, that the mimosa originates in Brazil.

But I can't nourish your eyes with mimosa light. So I beg you: please, see the mimosas that I see. Imagine the mimosas. See what you don't see, out of love for me. The mimosa is the painter's nymph.

I am the awkward sorceress of the invisible: my sorcery is powerless to evoke, without the help of your sorcery. Everything I evoke depends on you, depends on your trust, on your faith.

I gather words to make a great straw-yellow fire, but if you don't put in your own flame, my fire won't take, my words won't burst into pale yellow sparks. My words will remain dead words. Without your breath on my words, there will be no mimosas.

Ah! If I were Monet. I would fill your house with mimosas, with wisteria, with poppies. With palm trees. With straw. Only their fragrance would be missing.

I write. But I need the painter to give a face to my words. First of all, I write; then you must paint what I've said to you.

Am I jealous of the painter's power? Yes. No. I sense the terrific beating of the painter's heart, the vertigo, the urgency. It is perhaps what I like the most in painting: the beating of the heart. If I were a painter, what pain! What passion! What incessant jealousy of the sky, of the air, what torturous adoration of the light! If I were a painter I would see, I would see, I would see, I would see, I would be panic-stricken, I would run incessantly toward the potato fields, toward the pollard willows. If I were a painter I would know immediately that America is in the heath.

Since I am not a painter, I make detours and go through texts: "Do come and paint with me on the heath, in the potato field, come and walk with me behind the plough and the shepherd—come and sit with me, looking into the fire—let the storm that blows across the heath blow through you.

"Break loose from your bonds. I do not know the future, in what way it might be different if everything should go smoothly with us, but I cannot speak differently: Don't seek it in Paris, don't seek it in America; it is always the same, forever and ever exactly the same. Change, if you will, but it is in the heath you must look."[5]

That was Van Gogh.

I would roll around in desire and pain if I were a painter beneath the stars; if I were a painter I would die endlessly of wonder. I would live in ecstasy until it was at last granted to me to *no longer* see the stars, to no longer see the silk of gray-silver water crossed through and through by a fine strip of sun from my feet to the infinite, in the water, to no longer see the magnificence of sun-powder, until it was at last granted to me to stretch myself out in the dust, to rest among the marvelous powders of the earth. If I were a painter I would live in the fire, I would want to take up the fire in my hands. I would want to catch fire. I would end up losing my sight, and I would thank God. It's fitting that Monet painted with eyes closed, at the end of his life.

5.
The Complete Letters of Vincent Van Gogh, vol. 2 (Greenwich: New York Graphic Society, n.d.), 204. Cixous has slightly modified this translation.

I am nearsighted. And even if I have often blamed God for this, I often thank him for it. It's a relief. My nearsightedness spares me the agony of those who see the secrets of the sky. I write because I am nearsighted: it's also; I think, through nearsightedness, thanks to my nearsightedness, that I love:

I am someone who looks at things from very, very close up. Seen through my eyes, little things are very big. Details are my kingdoms. Some people survey. Some people who are far-seeing don't see what is very near. I am someone who sees the smallest letters of the earth. Flat on my stomach in the garden, I see the ants, I see each of the ants' feet. Insects become my heroes. Am I not a little bit right? Human beings are divine insects.

What is beautiful is that such little creatures can be so big.

Such are the benefits of my nearsightedness. This is how I console myself for not being a painter. Would I love this way if I were a painter?

6.
Monet, letter to Hoschede, in *Claude Monet at the Time of Giverny*, 36.

7.
Julie Manet, journal entry in *Claude Monet at the Time of Giverny*, 38.

How do I sense what I don't know—the painter's agony? The paintings are what tell me about the painter's passion. Not just *one* singular painting. But rather a series, a sheaf of paintings, a herd of paintings, a flock, a tribe of paintings. I see Monet's twenty-six cathedrals. I don't know if *one* cathedral would carry me away. Twenty-six cathedrals is a full gallop.

And I sense the struggle. I see the race of speed with the light. I see the challenge. I see the audacity.

The painter is the combatant of enigma.

The painter, the true painter, doesn't know how to paint. He looks for the secret. He will put his life into it. The painter is always Percival. He sets off, he leaves the forest, but in order to come back, on his way around the world, to the forest. I sense the painter's superhuman task: to capture the hundred cathedrals that are born in one day from the cathedral of Rouen. To see them being born. To see them succeeding one another. To see the cathedral in all its lights in one hour. It's to die for.

So he attacks the cathedral and the cathedral attacks him.

This is the struggle with the cathedral: "It's killing, and for this I give up everything, you, my garden... And something which never happens, my sleep was filled with nightmares: the cathedral fell down on top of me, it appeared either blue, pink or yellow."[6] And Julie Manet tells us: "Mr. Monet showed us his cathedrals. There are twenty-six of them, and they are magnificent. Some are entirely violet, others white and yellow, with a blue sky, or pink with a slightly green sky. Then there is one in the fog... You discover every detail in them; they are as if suspended in mid-air."[7]

Seeing the cathedral's truth which is twenty-six, and noting it, means seeing time. Painting time. Painting the marriage of time with light. Painting the works of time and light.

That's what I would like to do if I were a painter.

The sun moves so quickly. The cathedral changes so often. It was pink a short time ago. Now look at it, violet and flying low.

And we are so slow.

Life is so rapid.

"I doggedly keep exploring a series of different effects (of haystacks), but at this time of year the sun goes down so quickly that I cannot follow it."[8]

Following the sun, painting the differences. I see Monet attacking his poppy field, mounted on four easels. The paintbrushes fly about. Monet is racing.

And even as I have been writing this page, the sun has disappeared. We who write are so slow. And I think of the painter's magic swiftness.

Writing this, I said to myself that perhaps what I like about painting is its mad speed. And people will tell me, there are also slow painters. I don't know. I know nothing about it. I only imagine. But only those who are fast, those who pursue haystacks on four easels, matter to me.

And I think of the rapidity and fatality of desire: vying with light. "You need a Japanese swiftness." No, that wasn't Hokusai, but Van Gogh.

While I was writing this, I prudently held myself back from going out into all the fields that surround me, in order to avoid a too-great vertigo, and it was only when this brief reflection was over that I rewarded myself and wanted to reread Van Gogh's letters. I had been convinced that Van Gogh was a slow painter. Here is what I found:

> The Japanese draw quickly, very quickly, like a lightning flash, because their nerves are finer, their feeling simpler.
>
> … I have only been here a few months, but tell me this—could I, in Paris, have done the drawing of the boats *in an hour*? Even without the perspective frame, I do it now without measuring, just by letting my pen go.[9]

It is great that Claude Monet managed to paint those ten pictures between February and May. Quick work doesn't mean less serious work, it depends on one's self-confidence and experience.[10]

> I must warn you that everyone will think that I work too fast.
>
> Don't you believe a word of it.
>
> It is not emotion, the sincerity of one's feeling for nature, that draws us, and if the emotions are sometimes so strong that one works without knowing one works, when sometimes the strokes come with a continuity and a coherence like words in a speech or a letter, then one must remember that it has not always been so, and that in time to come there will again be hard days, empty of inspiration.
>
> So one must strike while the iron is hot, and put the forged bars on one side.
>
> I have not yet done half the 50 canvases fit to be shown in public, and I must do them all this year.
>
> I know beforehand that they will be criticized as *hasty*.
>
> … If my health doesn't betray me, I shall polish off my canvases, and there will be some that will do among them.[11]

8.
Monet, letter to Geffroy, in *Claude Monet at the Time of Giverny*, 80.

9.
The Complete Letters of Vincent Van Gogh, vol. 2, 590.

10.
Ibid., 596.

11.
Ibid., 598–99.

And to do that, what lightness must have been achieved!

For that, one has to have broken off with every-thing that holds one back: calculations, backward or sideways glances, hidden motives, acquired, accumulated, hardened knowledge. And especially all the fears: fear of the unknown, fear of criticism, fear of not knowing, fear of the evil eye: "They will say I am mad" (that's Monet). Fears, one shakes them off. One plays with them. One paints quicker than they take hold.

One does not paint yesterday, one does not even paint today, one paints tomorrow, one paints what will be, one paints "the imminence of."

And to do that, letting go of all ties, one flings oneself beyond the ego. This is perhaps the greatest lesson painting gives us: flinging oneself beyond the ego. For the ego is the last root preventing flight. Or the last anchor. One has to unfasten oneself the best one can, with a map, or by slowly filing away the soul-ring of lead.

I imagine it's easier for a landscape painter than for a writer to get free: the charm of the visible world is so powerful. At times, the painter's ego is no more attached than a milk tooth. A pull, and straight away, with a leap, in the middle of creation. We are born together. It's raining. We know nothing. We are part of everything.

"Under this fine rain I breathe in the innocence of the world. I feel coloured by the nuances of infinity. At this moment I am at one with my picture. We are an iridescent chaos… The sun penetrates me sound-lessly like a distant friend that stirs up my laziness, fertilises it. We bring forth life."[12]

That was Cézanne.

At that moment, when the ego no longer weighs him down, the painter becomes permeable, becomes immense and virgin, and becomes woman. He lets light work in him. Submission to the process. He becomes tender, he becomes plant, he becomes earth, the sun impregnates him. *Tanta mansidão*, such gentleness…[13]

But how do we obtain this lightness, this active passivity, this capacity to let things come through, this submission to the process? We who are so heavy, so obstinately activist, so impatient. How could we become virgin and young and innocent? How could we come all the way from our over-furnished memories and our museums of words to the garden of beginnings and rustlings?

This is our problem as writers. We who must paint with brushes all sticky with words. We who must swim in language as if it were pure and transparent, though it is troubled by phrases already heard a thousand times. We who must clear a new path with each thought through thickets of clichés. We who are threatened at every metaphor, as I am at this moment, with false steps and false words.

But there is a path. It makes us go around the world to regain the second innocence. It's a long path. Only at the end of the path can we regain the force of simplicity or of nudity. Only at the end of life, I believe, will we be able to understand life's secret. One must have traveled a great deal to discover the obvious. One must have thoroughly rubbed and exhausted one's eyes in order to get rid of the thousands of scales we start with from making up our eyes.

There are poets who have strived to do this. I call "poet" any writing being who sets out on this path, in quest of what I call the second innocence, the one that comes after knowing, the one that no longer knows, the one that knows how not to know.

I call "poet" any writer, philosopher, author of plays, dreamer, producer of dreams, who uses life as a time of "approaching." Fortunately, we have inher-ited rigorous accounts of their adventures. There are poet-painters, like Van Gogh. There are poet-painters like Clarice Lispector. Whoever would like to know how to go about clearing the gaze should read *The Passion According to G.H.*,[14] by Clarice Lispector.

30

12.
Paul Cézanne, quoted by Joachim Gasquet, in *Claude Monet at the Time of Giverny*, 308.

13.
See Lispector, "Such Gentleness," in *Soulstorm: Stories by Clarice Lispector*, trans. Alexis Levitin (New York: New Directions, 1989), 160–61.

14.
See Lispector, *The Passion Ac-cording to G.H.*, trans. Ronald W. Sousa (Minneapolis: University of Minnesota Press, 1988).

One must have gone a long way in order to finally leave behind our need to veil, or lie, or gild. Leaving behind the need to gild: this would be the passion according to Rembrandt.

In his very beautiful texts on Rembrandt, Genet says (still remaining within the tradition of reading Rembrandt) that the trajectory of Rembrandt's works began by gilding, by covering over with gold, and then by burning the gold, consuming it, to attain the gold-ash with which the last paintings are painted.

It is only at the end of the superhuman human-going-to-the-depths-of-the-fathoming-of-life-and-back that one will be able to cease gilding everything (Rimbaud and Clarice also knew this). And then one can begin to adore.

This is when one will be allowed to arrive at what I have called, in a text entitled *Lemonade Everything Was So Infinite*, "the last phrase," the one that holds on to the book or the author with no more than a breath. I have allowed myself to adventure toward the canvas partly because I had written this text, *Lemonade Everything Was So Infinite*. Because, in order to work on what is, for me, the very treasure of writing—in other words, ultimate phrases that are full of being, both so heavy and so light that they are more precious to me than an entire book; in order to work on the mystery of these phrases, I have been led to help myself with painting. I have not found any other more helpful example than some of the long journeys undertaken by painters, by Rembrandt in particular. And, arbitrarily or not, I had made a distinction between what I had called "works of art" and "works of being." For me, works of art are works of seduction, works that can be magnificent, works that are really destined to make themselves seen. Where I am arbitrary is in classifying this or that painter in this or that category. For example, for me, da Vinci's works are only works of art. This may be a mistake. But I will put forward a hypothesis: let us look at a painting by da Vinci and a painting by Rembrandt. We will see da Vinci's painting search us out with its eyes, not take its eyes off us, catch hold of us: these are eye-catching paintings.

In Rembrandt, what is overwhelming is the extent to which in the most intense presence, the people he has looked at are alone, have the absence of intimacy, do not feel themselves looked at; they are looking inside their hearts in the direction of the infinite. By going along this double path, I am now able to tell myself that what matters to me most, in art, are works of being: works which no longer need to proclaim their glory, or their magisterial origin, to be signed, to return, to make a return to celebrate the author. This was why, in the text where I dealt with that topic, I inscribed like a precious stone the phrase: "Lemonade everything was so infinite…," a phrase that signified everything to me, the beginning and the end, the whole of life, enjoy-ment, nostalgia, desire, hope—an *unsigned* phrase by Kafka, a phrase that fell from his hand, from his man's hand at the moment he was not striving to be a writer, the moment he was Franz Kafka himself, beyond books. If these phrases have been collected and printed in spite of everything, it is because it was God's will that, deprived of his voice, as he was dying, Kafka scribbled down, on scraps of paper, what was passing through his mind: and those who were with him at the moment of his passing collected those scraps of paper that are for me the most beautiful books in the world. Perhaps these so very delicate phrases, these phrases of a dying man, are the equivalent, extremely rare in writing, of what is much more frequent in painting: the last paintings. It's at the end, at the moment when one has attained the period of relinquishing, of adoration, and no longer of gilding, that miracles happen.

A magnificent thing happened to Hokusai:
In loving the pretentious style of He-ma-mu-sho-Niūdō, the painter Yamamizu Tengu, of Noshi-Koshiyama, appropriated for himself the incomprehensible art of his drawings. Now, I who have studied this style for almost a hundred years, without understanding any more of it than he, nevertheless had this strange thing happen to me: I notice that my characters, my animals, my insects, my fish, look as if they are escaping from the paper. Is this not truly extraordinary? And a publisher, who was informed of this fact, asked for these drawings, in such a way that I could not refuse him. Fortunately the engraver Ko-Izumi, a very skilled woodcutter, with his very sharp knife, took care to cut the veins and nerves of the beings I drew, and was able to deprive them of the liberty of escaping.[15]

15.
Le Fou de peinture: Hokusai et son temps, exh. cat., Centre Culturel du Marais (Paris: CRES, 1980), 217.

16.
A. Houbraken, in Horst Gerson, *Rembrandt et son oeuvre* (Paris: Hachette, 1968), 466.

What we have, when Hokusai was over two hundred years old, at the time when he was finally five or six years old, is a collection of drawings that scarcely hold back the beings, fish, insects, or men within their narrow limits.

In what way can I feel close to the painter (the one I love, the madman of painting, of drawing, the unworldly, the celestial, the airborne, the burning)?

First of all, in the need not to lie, not to veil in writing. Which doesn't mean I manage not to lie. It's so difficult not to lie when one writes. And maybe even in the need to write in order to lie less, to scrape the scales away, the too-rich words, to undecorate, unveil. In the need not to submit the subject of writing, of painting, to the laws of cultural cowardice and habit.

In the need, which doesn't mean its execution, not to make things pretty, not to make things clean, when they are not; not to do the right thing. But, whatever the price, to do the true thing.

Rembrandt, who is said not to have had particularly audacious tendencies, but who as a painter was absolutely free, drew and painted nude women I find admirably beautiful, although not everyone has been of this opinion. Here is what a contemporary, A. Houbraken, said in 1710:

Rembrandt... refused to conform to the rules of other artists, and still less to follow the illustrious examples of those who had covered themselves with glory by taking beauty as a model; he contented himself with representing life as it offered itself to him, without making a choice. This is why the great poet Andries Pels very wittily said of him in his *Use and Abuse of the Stage* (page 36): "Whenever he had to paint a nude woman, he took as a model not a Greek Venus but rather a washerwoman or servant girl from an inn: he called this deviation the imitation of nature and treated all the rest as vain decoration. From the sagging breasts and the deformed hands, to the frayed lace of the bodice opening across the stomach, to the garters around the legs—everything had to be shown, in order to remain faithful to nature. He did not want to listen to any of the rules of moderation that recommended the representation of only certain parts of the body."

I greatly appreciate Pels's frankness and I ask the reader not to misinterpret my sincere opinion: I do not hate the work of this man, but I wish to compare the different conceptions and methods of art, and to incite those who desire to learn to follow the best way. Apart from this, I join the same poet in saying: "What a loss for art that such a skilled hand did not use its gifts better! For who would have surpassed him? But the greater the genius, the more he can stray when he does not yield to any principles or to any traditional rule, and when he thinks he can find everything within himself."[16]

And to think that today, in our time, people think like this self-righteous biographer, but with a slight difference: painters are allowed to contemplate a woman's real nudity. But in writing, this is not yet entirely allowed.

What does my gesture of writing have in common with the gesture of one who paints?

The concern with fidelity. Fidelity to what exists. To everything that exists. And fidelity is equal respect for what *seems* beautiful to us and what *seems* ugly to us. I stress *seems*.

But under the paintbrush, before the gaze, in the light of respect, there is nothing ugly which does not seem equally beautiful.

Painting does not know the ugly.

It isn't the beautiful that is true. It's the true that is... I don't want to say beautiful. The ugly looked at with respect and without hatred and without disgust is equal to the "beautiful." The nonbeautiful is also beautiful.

Or rather, there is no beautiful more beautiful than the ugly. In painting as in writing, there is no other "beauty" than fidelity to what is. Painting renders—but what it renders is justice. Everything that is: the cathedral, the haystack, the sunflowers, the vermin, the peasants, the chair, the skinned ox, the flayed man, the cockroach.

Because everything that is loved, everything that finds grace, is equal to the "beautiful." Everything we don't reject.

We are the ones who decide that this is beautiful, that this is ugly. With our selfish tastes and distastes.

But everything is equal to God and to the painter. And this lesson is often given to the poet by painting. To love the ugly with an equal-to-equal love.

Everything that is (looked at justly) is good. Is exciting. Is "terrible." Life is terrible. Terribly beautiful, terribly cruel. Everything is marvelously terrible, to whoever looks at things as they are.

"I am toiling away at the rate of six paintings a day. I find it *terribly* difficult to catch all the colours of this country; at times, I am *appalled* at the kind of colours I have to use, I'm afraid my colours will seem *terrible* and yet I have considerably toned them down: this place is *drenched in light*... But how happy I am here because each day I can find the same effect again, *catch it and come to grips with it.*"[17]

That was Monet.

Seeing the world as it is demands strengths, virtues. Which ones? Patience and courage.

The patience one has to have to approach the nonostensible, the minute, the insignificant, to discover the worm as a star without luster. To discover the grasshopper's worth.

The patience one must have to see the egg. The egg that might bore us at first glance the way a stone would. One needs patience to contemplate the egg, to brood on it, to see the hen in the egg, to see the history of the world in this shell. One needs another patience to see the absolute egg, the egg without the hen, the egg without signs, the naked egg, the egg egg. And it is with this patience that we can hope to see God.

And the kind of courage?

The greatest kind of courage. The courage to be afraid. To have the two fears. First we have to have the courage to be afraid of being hurt. We have to not defend ourselves. The world has to be suffered. Only through suffering will we know certain faces of the world, certain events of life: the courage to tremble and sweat and cry is as necessary for Rembrandt as for Genet. And it is necessary for Clarice Lispector to have the courage to feel disgust and love the beggar with the amputated leg, disgust and love for the stump, horror at the rat which is also acceptance of the rat. For whoever writes, accepting the rat demands a far greater effort than for whoever has accepted the rat in advance, has begun to paint it. Whoever writes can easily hide her eyes. And there is also the other fear, the least dazzling, the most burning: the fear of reaching joy, acute joy, the fear of allowing oneself to be carried away by exaltation, the fear of adoring. We must not be afraid of feeling this fear scalding the blood in our veins.

I am talking about what we are given to see, the spectacle of the world. Maybe it's easier for a painter than for someone who writes not to create hierarchies.

Painting may be more adept at not forgetting turtles than writing is. Writing is terribly human. Perhaps the word causes more fear and more hurt?... I don't know.

17.
Monet, letter to Hoschede, in *Claude Monet at the Time of Giverny*, 33, emphasis added.

We can say joy. Can we paint it?

I'm talking about fidelity.

But perhaps the rarest, the most magnanimous fidelity, is the one we could have with regard to the reality of the human soul. It is so hard not to hate! Not to be the wolf for the other. To have for the traitor or the villain, the executioner, Rembrandt's calm and tender eyes for those who loved him, for those who betrayed him. Could Rembrandt be Shakespeare? I thought about it, thinking it was an impertinence. Van Gogh had thought about it before me.

> I have already read *Richard II, Henry IV* and half of *Henry V*. I read without wondering if the ideas of the people of those times were different from our own, or what would become of them if you confronted them with republican and socialist beliefs and so on. But what touches me, as in some novelists of our day, is that the voices of these people, which in Shakespeare's case reach us from a distance of several centuries, do not seem unfamiliar to us. It is so much alive that you think you know them and see the thing.
>
> And so what Rembrandt has alone or almost alone among painters, that tenderness of gaze which we see, whether it's in the "Men of Emmaus" or in the "Jewish Bride" or in some strange angelic figure as the picture you have had the good fortune to see, that brokenhearted tenderness, that glimpse of a superhuman infinitude that seems so natural there—in many places you come upon it in Shakespeare too. And then above all he is full of portraits, grave or gay, like "Six" and the "Traveler," and like "Saskia."[18]

That was Van Gogh shortly before his death.

To be faithful as Shakespeare was to Lady Macbeth, to King Lear, to Shylock.

To create without commentary, without condemnation, without interpretation.

With respect for the shadows as for the light. Without knowing more or better.

I envy the painter: humility, in other words the justice of the look, is more easily granted to him than to the one who writes; because the painter is always defeated. He sees himself defeated. He always emerges out of breath from the combat that throws him on the world. Doesn't he always have before him the painting he hasn't done? The twenty-seventh cathedral, to remind him that one cathedral will always have escaped him?

Doesn't he have before his eyes the painting he will not do, the one that slips by his brush? The one he will do tomorrow, tomorrow if God wills it, or never?

There are painters who for me are voyagers of truth. They have given me lessons.

Whom do I call the voyagers of truth?

The one who painted water lilies for the last ten years of his life. The one who painted water lilies up until the last painting. Until his death. And then: "The sea: I should like to always be before it or above it, and when I am dead, to be buried in a buoy."[19] That is Monet's wish—to become seagull, water lily.

The one who painted a hundred Fujiyamas. The one who signed the map of China: "Old man Manji crazy about painting, voyager from Katsushika, eight-one years old."

The one who searches until the last painting.

The one who paints with his right hand, his left hand, with his nails. This is Hokusai.

The one who knows that he will not find, because he knows that if he found, he would have nothing else to do except continue to search for the new mystery. The one who knows he must continue to search.

The one who does not become discouraged, does not tire.

I love the one who dares to stalk the secrets of light with the help of a single subject, armed with only a few water lilies.

And the lesson is: one does not paint ideas. One does not paint "a subject." One does not paint water lilies. And in the same way: no writing ideas. There is no subject. There are only mysteries. There are only questions.

Kandinsky sees the haystacks: "And suddenly, for the first time, my eyes were drawn to a painting… I had the confused feeling that the subject was lacking in this picture… The subject, as the necessary element of paintings, lost all credit to my eyes."[20]

18.

The Complete Letters of Vincent Van Gogh, vol. 3, 187.

19.

Monet, in *Claude Monet at the Time of Giverny*, 198.

20.

Wassily Kandinsky, in ibid., 80.

34

What a struggle to no longer "paint water lilies," while *painting* water lilies. I mean: in order not to do the portrait of the water lilies, what a number of water lilies we will have had to paint before the representation of the water lilies wears itself out, before the water lilies are no longer the cause, before they are no longer the object, the aim, but the occasion, the everyday water lily, the day itself, the day's atom on the canvas.

Until they are no more, these water lilies, than Hokusai's everyday lion. In 1843, at the age of eighty-three, Hokusai tells himself that it is time he did his lions, and every morning he does his karashishi: "I continue to draw hoping for a peaceful day"—that was the way he did two hundred nineteen of them, until the lions were no more than the water lilies' path toward infinity.

And how I love the one who dared to paint the painter, again and again, until at the hundredth "self-portrait" he succeeded in painting the painter impersonally; and yet ever so humanly, so nakedly human. Until we no longer think, "This is a portrait of Rembrandt by himself." Until at the hundredth portrait the name is so worn out that it no longer hides the man at all. And this man is as he is. He is old and absent-minded and, without proclaiming it and perhaps without knowing it, full of the mystery of age, time, and death.

I was in England during the Second World War, without any money and unhappy. My wife, who is younger and more courageous than I, said to me: "Let's go and look for consolation in a museum." Ruins were accumulating on the face of the earth. Not only was London being bombed—which was of little importance—but we learned every day of the annihilation of a new city. Devastation, destruction: the annihilation of a world becoming poorer and sadder. What bitterness. I looked at the last self-portrait of Rembrandt: ugly and broken, dreadful and full of despair; and so marvelously painted. And suddenly I understood: being capable of looking at oneself disappearing into the mirror—no longer seeing anything—and painting oneself as "nothingness," the negation of man. What a miracle, what a symbol. I drew courage and new youth from this.[21]

21.

Oskar Kokoschka, in Gerson, *Rembrandt et son oeuvre*, 478.

That was Kokoschka.

How much patience, how much time in order for Rembrandt to cease resembling Rembrandt, to cease clinging to Rembrandt, and little by little to let himself slide, without being frightened, into the resemblance of someone, of no one.

How much greater a love for painting than for oneself! To come as far as the portraits of a man who allows himself to look, who allows himself to paint, who gives himself to be painted, by renouncing himself, who gives himself to painting as others do to God. And as the dead man does to science. So that it can advance on his body.

Perhaps Rembrandt dreamed of doing the last portrait of the painter? The one that only Rembrandt, at the end of his life, could have done? I dream of it.

The portrait of Rembrandt on his deathbed? For it is at this moment that he would have perceived the most anonymous, the most present, the most immediate, the most ephemeral, the essential, the mystery of human being. And if almost dead or already dead, in other words entirely freed from the rest of the Rembrandt he had painted, then he would have painted painting itself. He would truly have painted like no one.

22.
Unpublished notebooks of Lispector, cited in Olga Borelli, *Clarice Lispector: Esbogo para um possivel reltalo* (Rio de Janeiro: Editora Nova Fronteira, 1981), 77.

23.
Ibid., 77.

24.
Le Fou de peinture, 376.

I dream of this purity. I dream of this power of freedom. To paint the enigma. The enigmatic in painting. I think of the last Rembrandt. A man? Or a painting? I think of the last Hokusai. What is the name of the person who painted the last Hokusai?

I think of Hokusai's series of names like the series of water lilies. He had a hundred and one names. First he was called Shunro. Then, expelled from school, took the name Kusamara. Took the name Sori in '95. Hokusai Sori-ga, which means Studio of the North Star, Source of Truth; also called himself Toito, Litsu, Zen Hokusai, Gakyojin Hokusai, then Tawaraya, Hyakurin, Kanchi, and Sori.

Then abandoned the name Sori to his pupil. And called himself Tatsumasa, Sorobeku, Tokitaro, Gayojin Totogako Zen Hokusai, Sensei Kutsushika Taito, Zen Hokusai Tasmeitsu Gakyorojin Manji. All these names had a meaning. Not one was Hokusai.

Following himself without turning back. One after the other letting himself go.

Always being the future. Being the follower. The next one. Being one's own next one. The unknown one. Surpassing oneself. And yet not preceding the self. Abandoning oneself. In words. In curves. Abandoning one's names. One's signatures. Giving oneself entirely to rediscovery.

And so, in the course of time, what does this produce? What does this produce in the end?

A possibly mad purity.

One can tell the facts. One can invent some. It is more difficult to tell than to invent. Inventing is easy.

But the most difficult is fidelity to what one feels, there, at the extremity of life, at the nerve endings, around the heart.

And for that, there are no words. For what one feels, there are no words. For the reality of the soul, there are no words. But there are tears. One can allude to the divine. But the word "god" is only a subterfuge.

Words are our accomplices, our traitors, our allies. We have to make use of them, spy on them, we should be able to purify them.

This is the dream of philosophers and poets. Words drive us mad. "By repeating a word over and over again, it loses its meaning and becomes a hollow and redundant thing, and attains its own hard, enigmatic body."[22]

Clarice amused herself by saying, "Spirit, spirit, spirit." And in the end, spirit flew. In the end, what is spirit?

"It is a sparkling and audacious word, like a flight of sparrows. Sometimes the repeated word becomes the dry orange-skin of itself, and no longer glows with even a sound."[23]

What happens at the end of two hundred nineteen lions? What happens at the end of ten thousand or a hundred thousand water lilies?

I claim the right to repeat the word until it becomes dry orange-skin, or until it becomes fragrance. I want to repeat the words "I love you" until they become spirit.

But repetition, in those who write, is very badly received. The painter has the right to repeat until water lilies become divine sparrows.

To practice abandoning oneself to the water lilies.

Perhaps in the end that would give the portrait of God, or the self-portrait of God by Hokusai.

When Hokusai produced the hundred views of Mount Fuji, this is what he said:

> From the age of six, I had a passion for drawing the form of objects. By the age of about fifty, I had published an infinity of drawings, but nothing I produced before the age of seventy is worth counting. It was at the age of seventy-three that I more or less understood the structure of true nature, of animals, grasses, birds, fish, and insects.
>
> Consequently, by the age of eighty, I will have made even more progress; at ninety I will penetrate the mystery of things; at a hundred I will definitely have reached a degree of wonder, and when I am a hundred and ten, for my part, be it a dot, be it a line, everything will be alive.
>
> I ask those who will live as long as I do to see if I keep my word.
>
> Written at the age of seventy-five by myself, formerly Hokusai, today Gwakiō Rōjin, the old man crazy about drawing.[24]

This is truly the message of hope. It gives me a great deal of hope, I tell myself that when I am a hundred and ten, I will likewise know how to write a book that will be a dot.

Painting and writing—they are just that, hoping absolutely, they are what we might call *sunflower life*, to borrow an image from Van Gogh or from Clarice Lispector: "Almost all lives are small. What enlarges a life is the inner life, are the thoughts, are the sensations, are the useless hopes… Hope is like a sunflower which turns aimlessly toward the sun. But it is not 'aimless.'"[25]

What enlarges a person's life are the impossible dreams, the unrealizable desires. The one that has not yet come true. And these hopes, these desires are so strong that at times one falls, and when a person falls, she sees, she is once again turned toward the inaccessible sun. Why does the flower have a fragrance that is not for anyone, and for nothing…

Like hope. Hope aims at hope itself.

And the painter? Paints from hope to hope. And between the two? Is there despair? Nonhope. Between-hope. But straightaway, hope arises. What I love is the painter's dissatisfaction, what a wonder: a furious Monet burning thirty canvases. Destroying his "overworked" canvases.

Seen by us, these canvases were "beautiful." Seen by him, they are obstacles on the path to the last one.

His dissatisfaction is hope. Hope for the impossible. To turn oneself once again toward the sun is an act of faith. Writing the sun is as impossible as painting the air. This is what I want to do.

When I have finished writing, when I am a hundred and ten, all I will have done will have been to attempt a portrait of God. Of the God. Of what escapes us and makes us wonder. Of what we do not know but feel. Of what makes us alive. I mean our own divinity, awkward, twisted, throbbing, our own mystery—we who are lords of this earth and do not know it, we who are touches of vermilion and yellow cadmium in the haystack and do not see it, we who are the eyes of this world and so often do not even look at it, we who could be the painters, the poets, the artists of life if only we wanted to; we who could be the lovers of the universe, if we really wanted to use our hands with mansuetude, we who so often use our booted feet to trample the world's belly.

We who are bits of sun, drops of ocean, atoms of the god, and who so often forget this, or are unaware of it, and so we take ourselves for employees. We who forget we could also be as luminous as light, as the swallow that crosses the summit of the incomparable hill Fuji, so intensely radiant that we could ourselves be the painter's models, the heroes of human presence and the painter's gaze. But what we forget, the painter, who sees God each day in the process of changing, does not forget…

In what way do I feel different from these painters I love? In my way of loving an interior apple as much as an exterior apple.

"I received today a splendid apple, sent by Mr. Bellio; by its size and colours it is quite a phenomenon: he tells me that amidst so many orange trees I might feel like biting into a big apple from Normandy, hence his nice present.

"I did not dare to bite into it and offered it to Mr. Moreno."[26]

That was Monet.

Myself, I would have eaten it. In this way, I am different from those I would like to resemble. In my need to touch the apple without seeing it. To know it in the dark. With my fingers, with my lips, with my tongue.

In my need to share with you the food, the bread, the words, the painted food and also the not-painted food.

In my need to make use of my right hand to hold the pen and write, and of my two hands to hold nothing, so caress and to pray.

I am going to finish…

I have a postscript, Hokusai's address. In case, having reached the age of a hundred and ten, we are looking for him, here it is:

"When you come, do not ask for Hokusai; they will not know how to answer you. Ask for the priest who draws and who recently moved into the building, ask the owner Gorobei for the beggar-priest in the courtyard of the Mei-o-in temple, in the middle of the bush."[27]

May I have merited such an address… by the time I am ninety years old…

25.
Lispector, in Borelli, *Clarice Lispector*, 21.

26.
Monet, letter to Hoschede, in *Claude Monet at the Time of Giverny*, 31.

27.
Le Fou de peinture, 361.

Plates

*she taking her space (after Michael Joyce's
"he taking the space of," 2004), 2004*

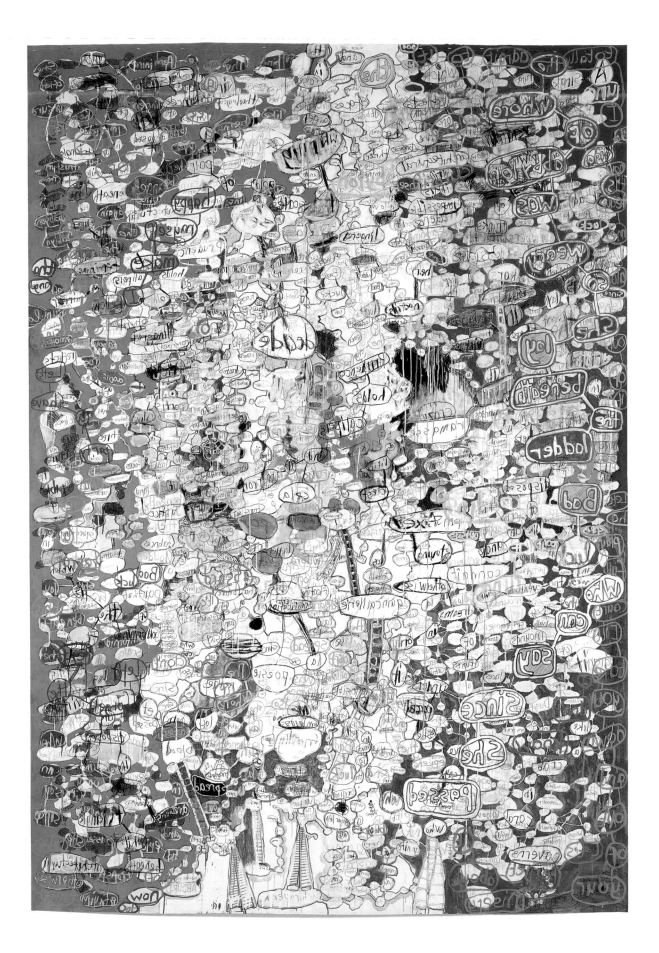

she taking her space (after Michael Joyce's
"he taking the space of," 2004), 2004, detail

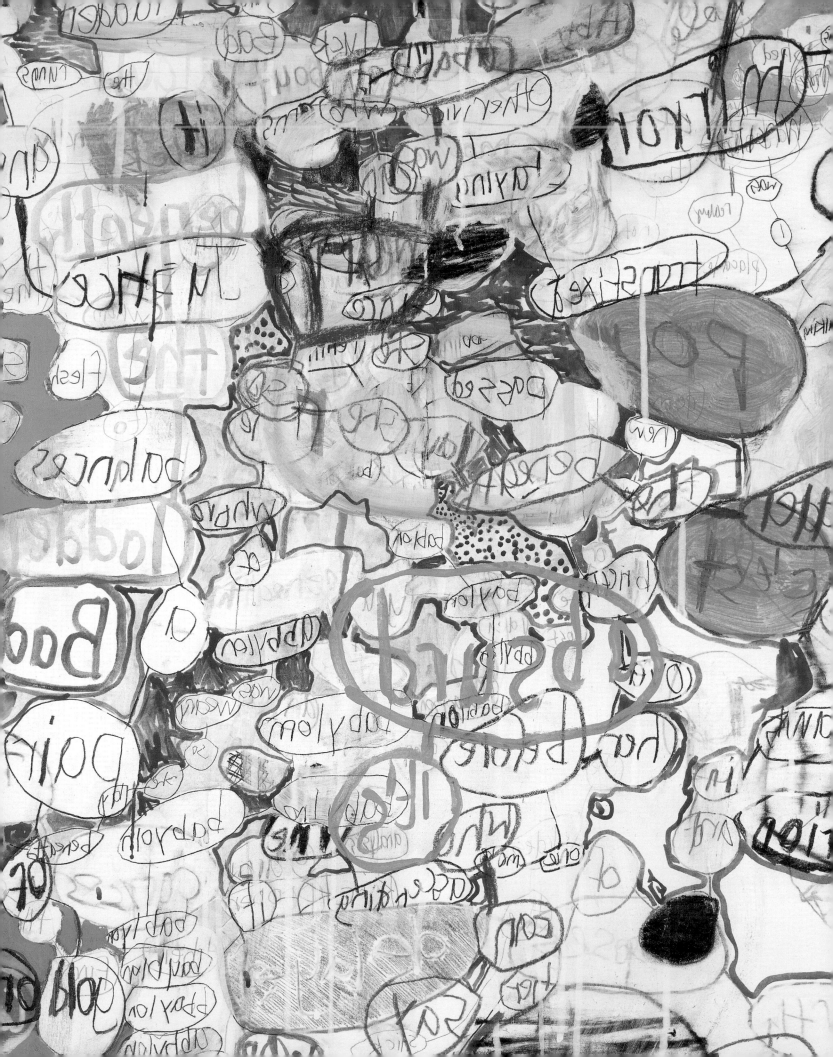

let's (after Michael Joyce's "Ladders," 2004), 2005

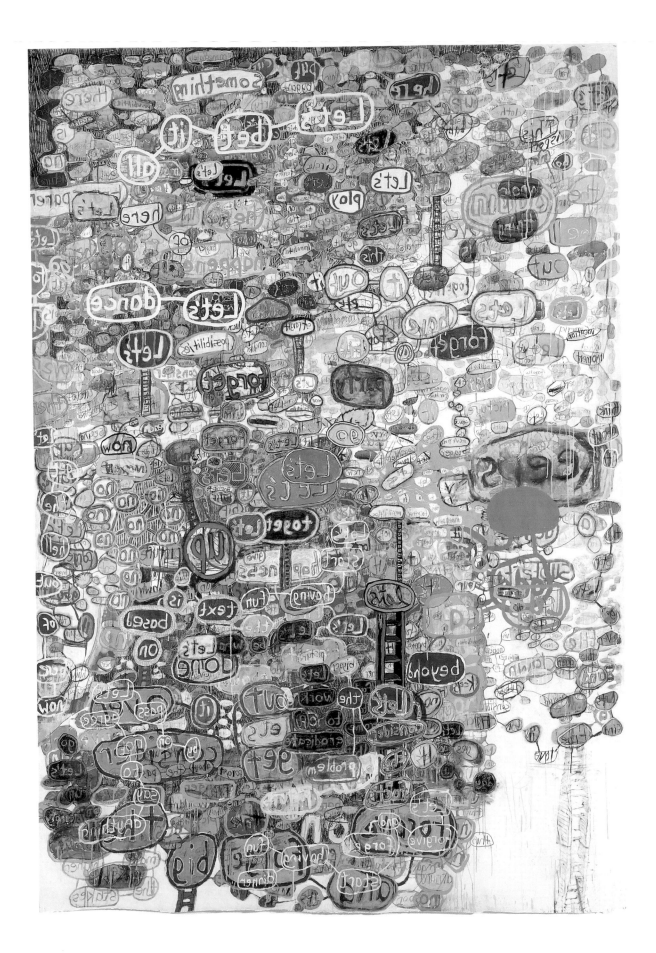

let's (after Michael Joyce's "Ladders," 2004), 2005, detail

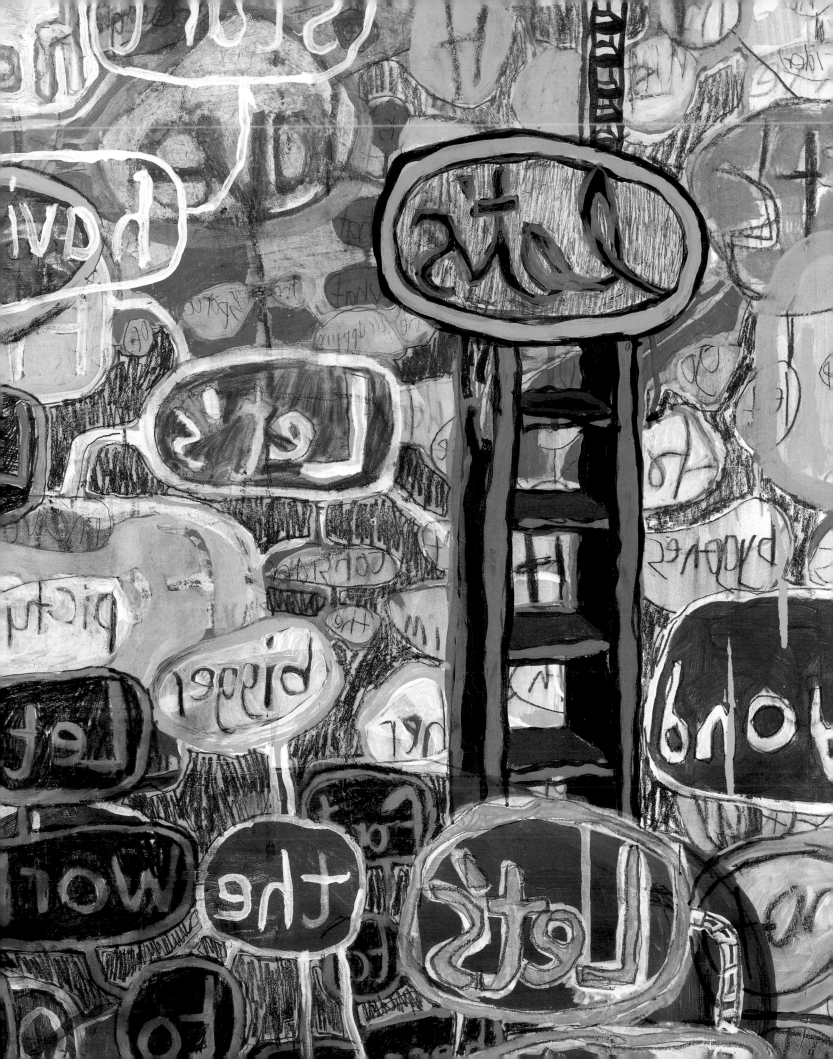

conspirar (after Michael Joyce's "Conspire," 2004), 2005

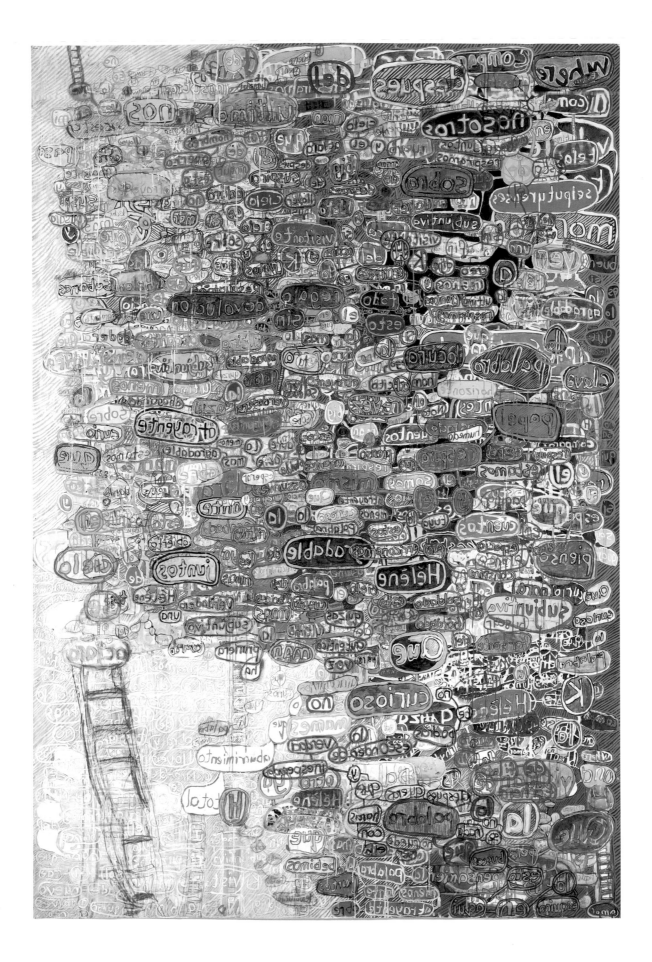

conspirar (after Michael Joyce's "Conspire," 2004), 2005, detail

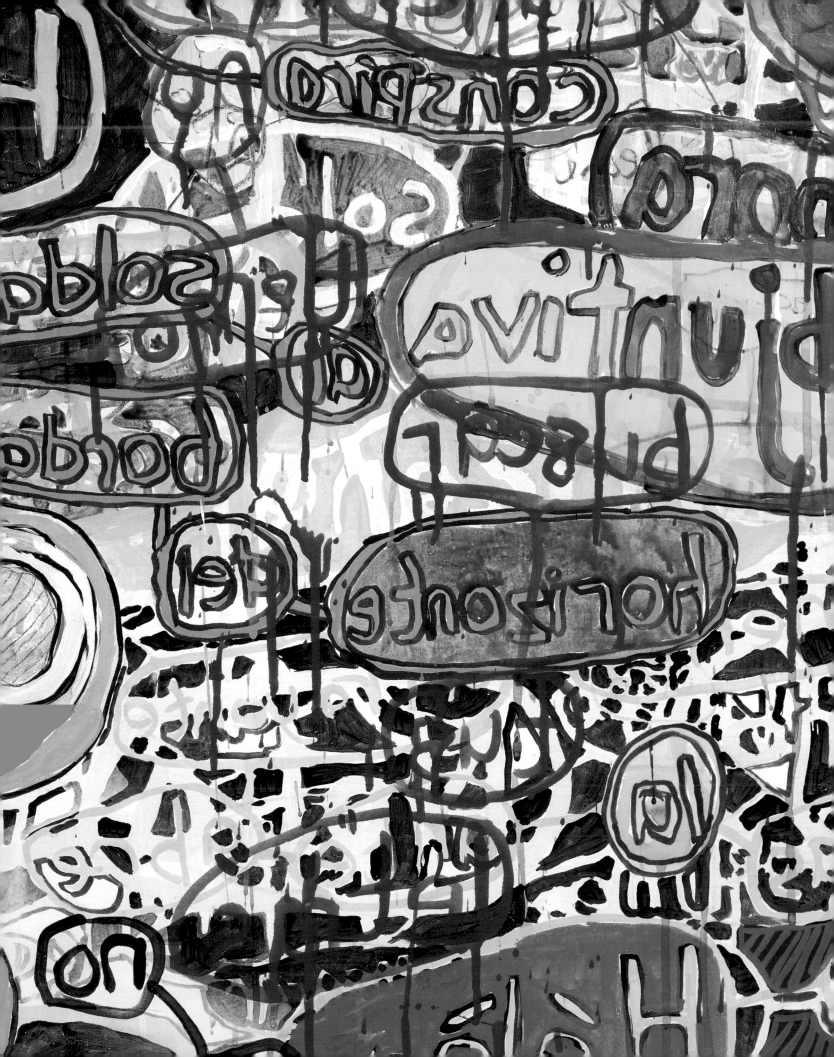

contender (after Michael Joyce's "Contend," 2004), 2005

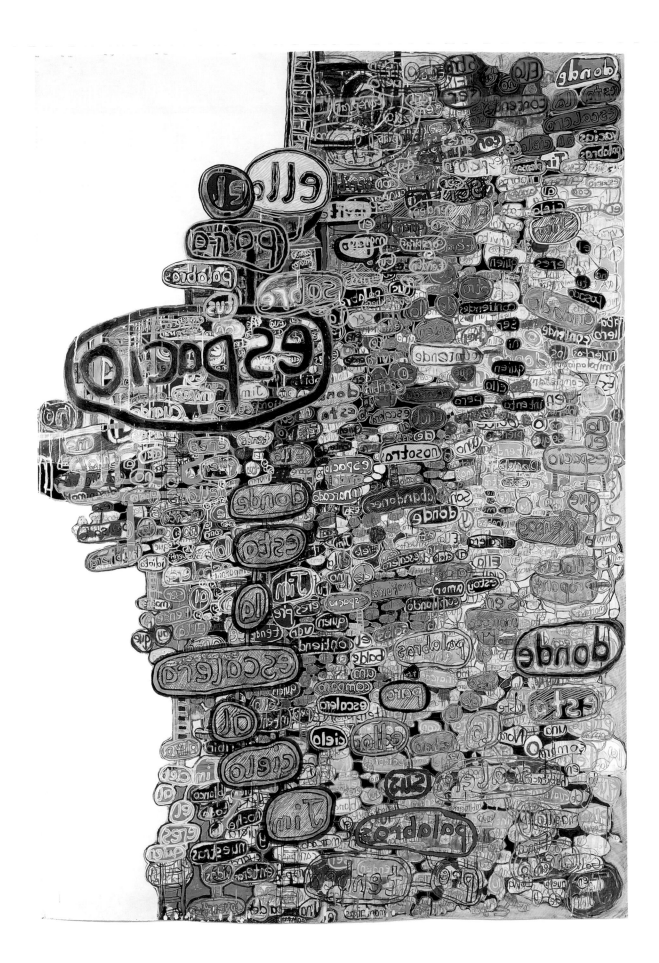

contender (after Michael Joyce's "Contend," 2004), 2005, detail

54

OVERLEAF

¿dónde está la escalera al cielo?, 2007, detail

GATEFOLD

babel (after Michael Joyce's "Was," 2006), 2006

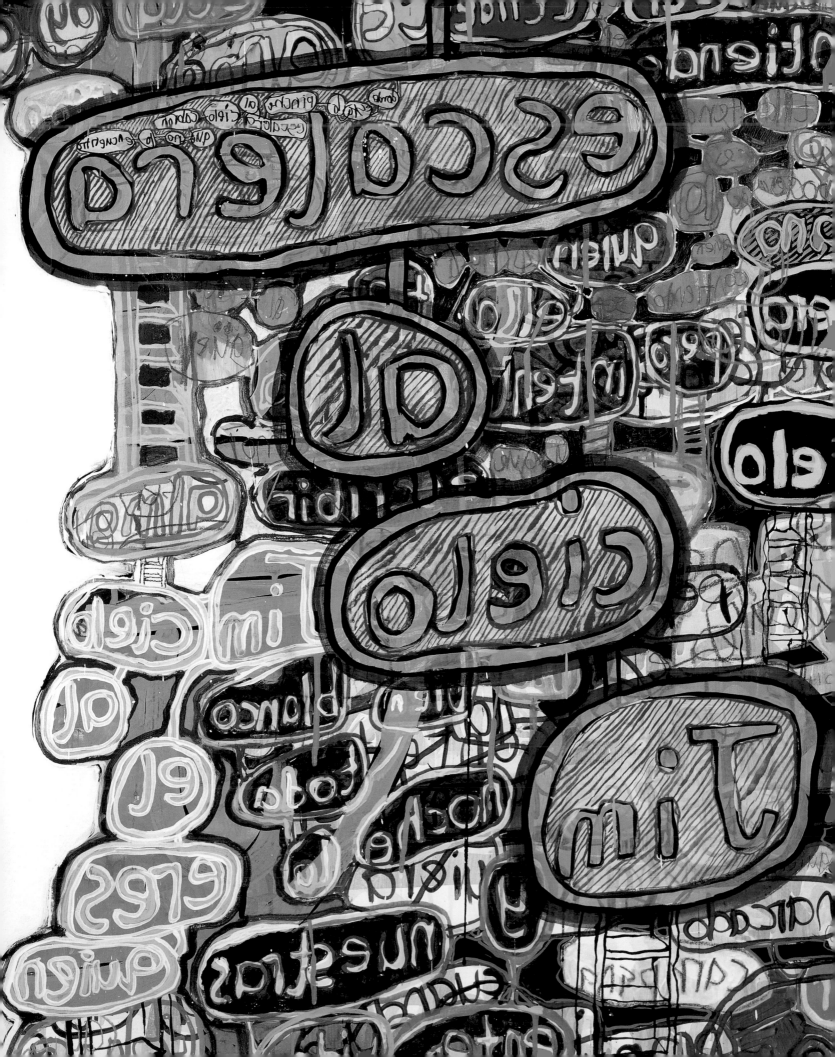

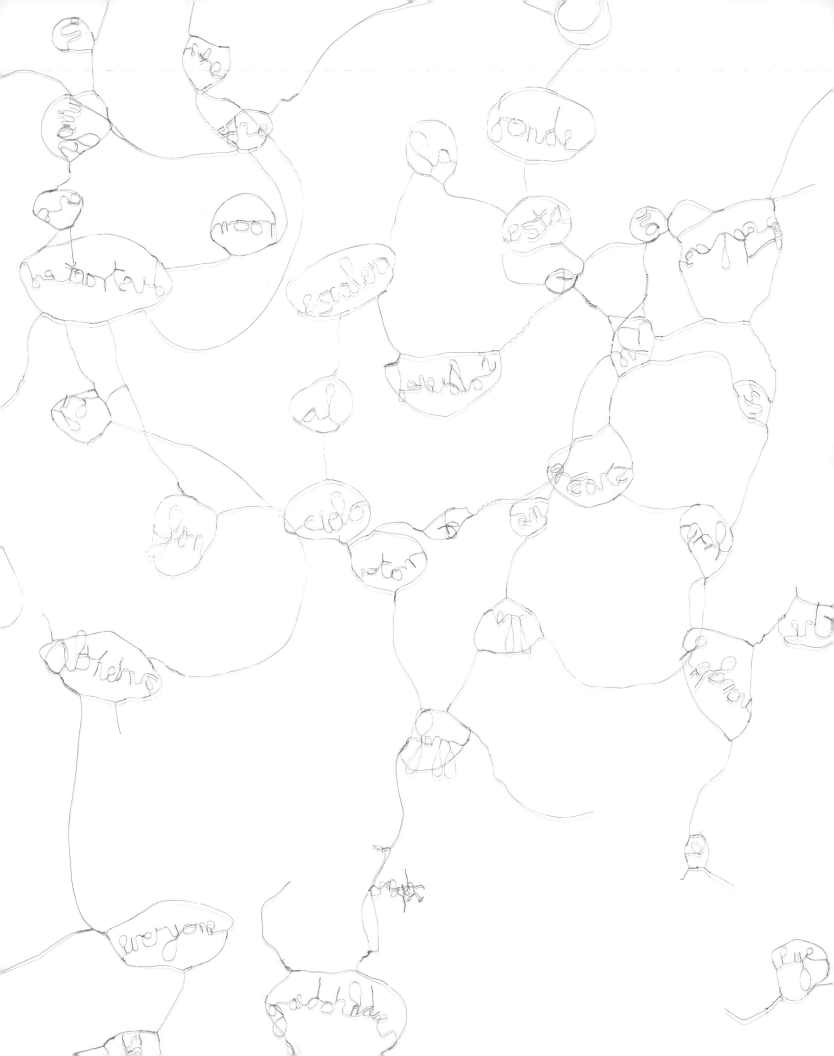

Twin Portraits at the Periphery of a Flux (Fifth Iteration)
(after the texts "Twin Portraits at the Periphery of a Flux,"
"Untitled Song," and "Fluxus Score" by Michael Joyce, 2006,
and "Observatory" by Robert Watts), 2006

Mixed media on paper
122 x 80 inches
Collection of the artist, Los Angeles

66

Twin Portraits at the Periphery of a Flux (Fifth Iteration)
(after the texts "Twin Portraits at the Periphery of a Flux,"
"Untitled Song," and "Fluxus Score" by Michael Joyce, 2006,
and "Observatory" by Robert Watts), 2006, detail

Mixed media on paper
122 x 80 inches
Collection of the artist, Los Angeles

68

she taking her space (after Michael Joyce's "he taking the space of," 2004), 2004
Mixed media on paper
120 x 80 inches
The Museum of Contemporary Art, Los Angeles
Purchased with funds provided by the Drawings Committee

conspirar (after Michael Joyce's "Conspire," 2004), 2005
Mixed media on paper
126 x 80 inches
Collection of the artist, Los Angeles

contender (after Michael Joyce's "Contend," 2004), 2005
Mixed media on paper
126 x 80 inches
Collection of the artist, Los Angeles

let's (after Michael Joyce's "Ladders," 2004), 2005
Mixed media on paper
120 x 80 inches
Private collection, Los Angeles

babel (after Michael Joyce's "Was," 2006), 2006
Mixed media on paper
80 x 264 inches
Collection of the artist, Los Angeles

¿dónde está la escalera al cielo?, 2007
Paper
Dimensions variable
Collection of the artist, Los Angeles

nimbus II (after Michael Joyce's "Nimbus," 2003), 2007
Wire, shadow, motor, and light
80 x 62 inches
Collection of the artist, Los Angeles

SELECTED EXHIBITION HISTORY AND BIBLIOGRAPHY

EDUCATION

MFA, drawing and painting, California College of Arts and Crafts, San Francisco, 2000

BA, history and studio art, Swarthmore College, Swarthmore, Pennsylvania, 1995

SOLO EXHIBITION

"Homecoming," Gallery Sixteen:One, Santa Monica, California, 20 March–18 April 2004

SELECTED GROUP EXHIBITIONS

2006

"Draw a Line and Follow It," Los Angeles Contemporary Exhibitions, Los Angeles

"Flourish," Torrance Art Museum, Torrance, California

"Labirinti, Amelia: La Fiber Art al Centro," Biennale di Arte Tessile Contemporanea, Museo Archeologico, Amelia, Italy

"Painting Fiction, Fiction Painting," The Brewery Project, Los Angeles

2005

"Conceptual Writing," Van Ackeren Gallery, Rockhurst University, Kansas City, Kansas

2004

"Northwest Territories," Armory Center for the Arts, Pasadena, California

"Freewall," Kellogg University Art Gallery, California State Polytechnic University, Pomona, California

"page_space," Machine Project, Los Angeles

"Encoded," Fe Gallery, Pittsburgh

2003

"Painting by Letters," Cirrus Gallery, Los Angeles

"Open Haus," Haus Gallery, Pasadena, California

"Mind's Eye," SolwayJones Gallery, Los Angeles

2002

"unDRAWN: unusual approaches to drawing," The Brewery Project, Los Angeles
"Reading Room," Southern Exposure, San Francisco

"Wall Space 2," Miller Durazo Contemporary Artists Projects, Los Angeles

"irrational propositions," POST Gallery, Los Angeles

"maps & charts," Tyler School of Art, Temple University, Philadelphia

2001

"drawing in residence," Wintergarten Galerie, Vienna

2000

"evictions," 160 Minna Street, San Francisco

MFA Show, California College of Arts and Crafts, San Francisco

1999

"Index," CCAC Graduate Gallery, San Francisco

SELECTED BIBLIOGRAPHY

Cutajar, Mario. "Painting by Letters." Available at http://artscenecal.com/ArticlesFile/Archive/Articles2003/Articles1103/PaintingsByLettersA.html.

"Five Artists to Buy NOW." *C Magazine* (October 2005).

Grant, Alexandra, and Michael Joyce. "Indecretions." *Notre Dame Review*, no. 19 (winter 2005): 106–07.

Myers, Holly. "Words, Words, Words, Rising Aloft." *Los Angeles Times*, 23 March 2004.

Soderman, Braxton. "Page_Space Intoduction." Available at http://machinepoetics/page_space/introduction.

"'What is conceptual writing?' A project organized by Debra di Blasi." *Kansas City Review* 7, no. 4 (March 2005): 34.

Zellen, Jody. "Homecomings: Alexandra Grant at Sixteen: One." *d'Art International* (winter 2004–05): 34.

babel (after Michael Joyce's "Was," 2006), 2006, detail